Sculptural Bookmaking

This accordion-style book was prompted by a concern about the destruction of local snake habitats. Red houses pop up and away from a black background, while green snakes rise above a mountain-like sculptural form. (For directions on making an accordion book, see chapter seven.)

Sheril Cunning, *Whose Land Is It Anyway?* 1985. Mixed media on paper, 40 x 6" (101.6 x 15.2 cm).

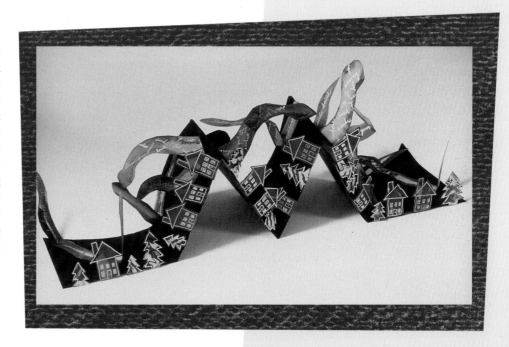

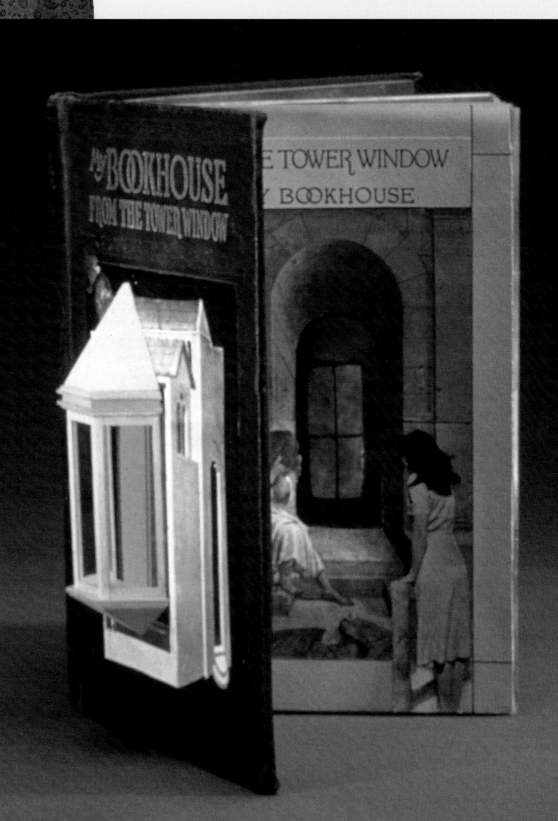

Sculptural Bookmaking

Ann Ayers and
Ellen Easterling McMillan

Davis Publications, Inc. • Worcester, Massachusetts

Dedication

To Dr. Clem Pennington, our teacher, our mentor, and our friend.

Copyright © 2003
Davis Publications, Inc.
Worcester, Massachusetts, U.S.A.

Publisher: Wyatt Wade
Editor-in-Chief: Claire Golding
Editorial Director: Helen Ronan
Developmental Editor: Nancy Wood Bedau
Production Editor: Carol Harley
Manufacturing Coordinator: Georgiana Rock
Copyeditor: Janet Stone
Designer: Nancy Wood Bedau
Page Layout: Karen Durlach
Photography: John J. Lopinot
Editorial Assistance: Jillian Johnstone

Library of Congress Catalog Card Number: 2003104692
ISBN: 0-87192-613-X
10 9 8 7 6 5 4 3 2 1
Printed in the United States

Title Page In this work, the artist has literally transformed a book into sculpture. An arched shape is cut through layers of paper to form a window; a glowing orange background warms the depths. A lovely statement about the potential magic of books invites the viewer to walk right into the story.

Terry Braunstein, *My Bookhouse: From the Tower Window*, 1992. Photomontage, mixed media, altered book, 9 1/2 x 7 x 2" (24.1 x 17.8 x 5.1 cm).

Special thanks to:

- our very talented photographer, John J. Lopinot, for his patience, professionalism, and ability to capture the best qualities of each sculptural book.

- Judith Hoffberg and the many book artists who shared their work and their vision with us.

- our friends Bruce Gambill and June Reichenbach for their awesome books!

- Nancy Wood Bedau and Helen Ronan, our editors, and Davis Publications for giving us the opportunity to introduce the art of sculptural bookmaking to a new audience.

- all of our many students at Coral Springs High School, Coral Springs, Florida, and Parkway Middle School of the Arts, Fort Lauderdale, Florida, for their excitement, curiosity, and creativity and for their willingness to embrace new ideas and concepts!

From Ellen

A special thank you to my parents, Gene and Anne Easterling, for artistically guiding me and encouraging me throughout my life. I also want to thank my own family, Mike, Liberty, and Darien McMillan, for their patience throughout the years while I was presenting workshops, attending classes, producing artwork, and preparing this book for publication. I also extend my appreciation to all of my art instructors since my years at Lakeview High School in Decatur, Illinois, and through my years at Illinois State University and Florida International University.

From Ann

Many, many thanks to my wonderful family: my husband, Jeff, and daughters, Amy, Julie, and Jenny, for their continual love, support, and belief in me! I also would like to thank my parents, Al and Marge Lopinot, my sister, Mary McClintock, my brother, John Lopinot, and my mother-in-law, Frances Nereo, for their encouragement, love, and direction. And finally, a special thanks to my art instructors and my colleagues at Southern Illinois University, Florida International University, and Coral Springs High School.

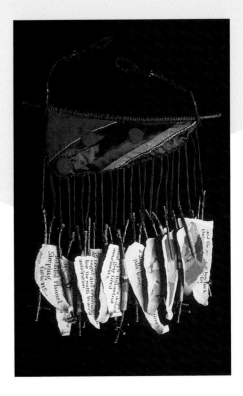

This innovative work combines an interest in fiber art with sculptural bookmaking. Messages are written on a row of "pages" that are strung like beads on a necklace.
Janet Pyle, *Detailed Flannel Sleeping Gowns*, 1991. Watercolor paper, ink, acrylic paint, fabric, wool yarn, wood, wire, collage paper, 13 x 12 x 1" (33 x 30.5 x 2.54 cm).

Contents

About this work, the artist comments, "During a difficult period with my family, I wrote (as I would in a journal) my frustrations with the situation. The writing is illegible so that it could not be read after I wrote it. It's a cathartic process." (For ideas on creating your own journal, see chapter three.)

Nancy Pobanz, *Those Ties That Bind*, 1999. Found wooden box, flax paper with soil pigment, linen threads and tapes, handmade papers, bookcloth, displayed open: 21 x 12 3/4 x 8" (53.3 x 32.4 x 20.3 cm). Photograph by Lightworks Photography.

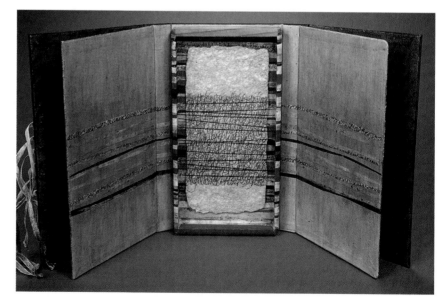

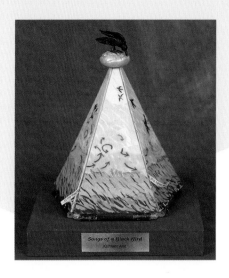

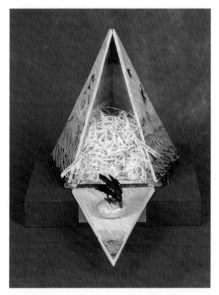

Beginning as a sculptural form, this book unfolds in stages to become a star-shaped nesting place for the subject of the book: the blackbird.

Kathleen Amt, *Songs of a Black Bird*, 1996. Polymer clay, 8 ¹/2 x 7 x 7" (21.6 x 17.8 x 17.8 cm). Photograph by Martin P. Amt.

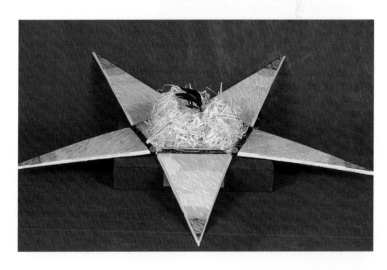

Introduction

The term "sculptural book" refers to any type of book that is meant to be seen as a piece of three-dimensional art. The transition of the book from a literary work to an avenue for creative visual expression has been well documented throughout the last decade. Some book artists have remained true to the book as a source for image and word, while others have seen this format as a means to create contemporary art and imagery. Some choose to present their work exclusively without text.

The human fascination with books may well remain a mystery. Perhaps books rekindle childhood experiences with the magic of storytelling. Possibly books symbolize an individual, personal attachment to something that can be revisited and read time and time again—something that we can write or draw in, travel with, or stow away. Some artists create books to be viewed and shared, others use the book format for private self-expression.

This book explains several bookmaking techniques in detail. Ideas for themes and suggestions to spur creative thinking are also given. The first two chapters of this book provide a brief history of artists' books and offer motivation and inspiration for beginning a sculptural book.

Chapter three explores new insight into the creation and use of a personal journal or sketchbook, one that breaks the mold of a traditional approach. Creating your own "sculptural" journal may make you feel more involved, more committed to using the book and to viewing it as a work of art in itself.

Chapter four reviews the materials, tools, and equipment you need to create your own sculptural book.

In Part Two, we get down to business! Since the paper you use can make the biggest difference in the quality of your work, we start with techniques for dyeing and decorating your paper in chapter five. Chapter six reviews the basics for making covers. Although this step is generally last in the process, you will want to plan for cover materials when decorating paper for your book. The same basic steps apply to all the covers you will make for each of the projects that follow.

Chapters seven through fifteen provide detailed, step-by-step information on how to make several different types of sculptural books. Specific directions, including paper measurements, are given for each book. However, feel free to alter sizes, shapes, or other aspects of the books. These projects are meant as a starting point for you to generate your own ideas.

The last chapter reviews the process of creating a slipcase and other finishing touches for your sculptural book. Created last but seen first, a slipcase can make all the difference in first impressions, giving a hint as to what is inside your book.

Throughout the text, a pictorial gallery of unique books introduces the unlimited possibilities of the medium. These artists have gone beyond the traditional book form and have stretched the idea to the most creative limit. We hope this book will inspire you to many creative adventures of your own. Have fun!

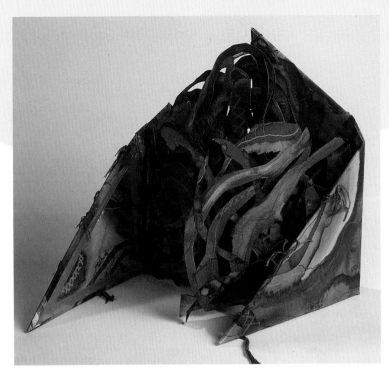

In this extreme variation of the pop-up book (chapter 11), the artist designed a unique cover that is split down the middle along a diagonal cut. Learn how to make your own richly colored dyed paper in chapter 5.
Ann Ayers, *Secret Garden*, 1990. Mixed media, 13 x 16" (33 x 40.6 cm).

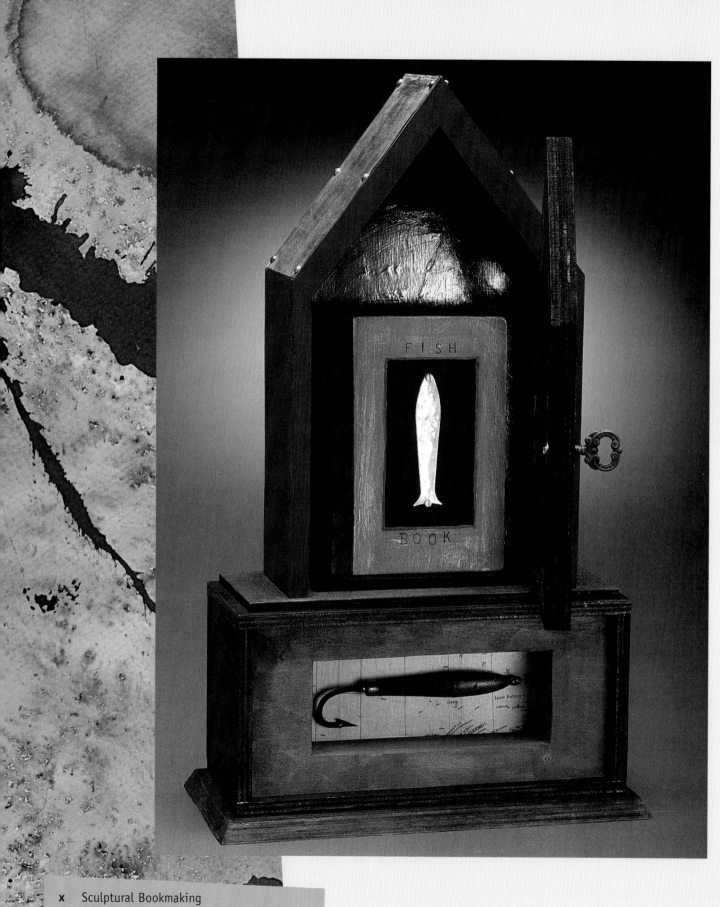

Part One: Why Sculptural Books?

P–1 Some sculptural books more closely resemble books, while others look more like independent sculptures. How the book is contained or displayed can make a big difference. *Fish Book* is a ten-page book with fish imagery, bound with a wooden cover, and displayed inside a wooden box with a glass door. A fish lure displayed below it provides a finishing touch. (For display case ideas, see chapter fifteen.)

Laura Davidson, *Fish Book*, 1993. Mixed media, 17 x 10 x 5" (43.2 x 25.4 x 12.7 cm).

1 A Peek at History

As early as the fifteenth and sixteenth century, publishers, printers, and typographers were producing books that combined art and the written word. Although these books were a technical accomplishment and well-made in terms of design, printing, and bookbinding, none could be considered an "artist's book." An artist's book is an artwork in which the artist uses the form of a book as a means of expression.

The poet and artist William Blake was one of the first artists to use the book as an art form. In the late eighteenth century, Blake combined his experience with engravings and printmaking with his literary skills. He created books that wed visionary art with the written word. In the late nineteenth century, William Morris envisioned the book as a vehicle for social and spiritual expression. Concentrating on good typographical design and printing, Morris merged art and craft in his books.

During the mid-1890s, publisher and art dealer Ambroise Vollard published the first *livres d'artiste,* or fine art books. Vollard worked on publications with Georges Rouault, Pablo Picasso, and Marc Chagall. These works were traditional in structure and were often collaborations between artists and writers.

Daniel-Henry Kahnweiler, another art dealer and publisher, was an important figure in the modern art world and an early supporter of Cubism. Kahnweiler liked the challenge of working with avant-garde artists, including then

1–1 For poet and artist William Blake, the book format was an ideal way to express his spiritual beliefs. This page from one of his books contains a poem he wrote and illustrated himself, then printed in green ink and finished in watercolor. The porous quality of the paper causes the ink to fade into it a bit, giving the image a soft look.
William Blake (1757–1827), *The Divine Image,* from *Songs of Innocence.* Bridgeman Art Library, Library of Congress, Washington, D.C.

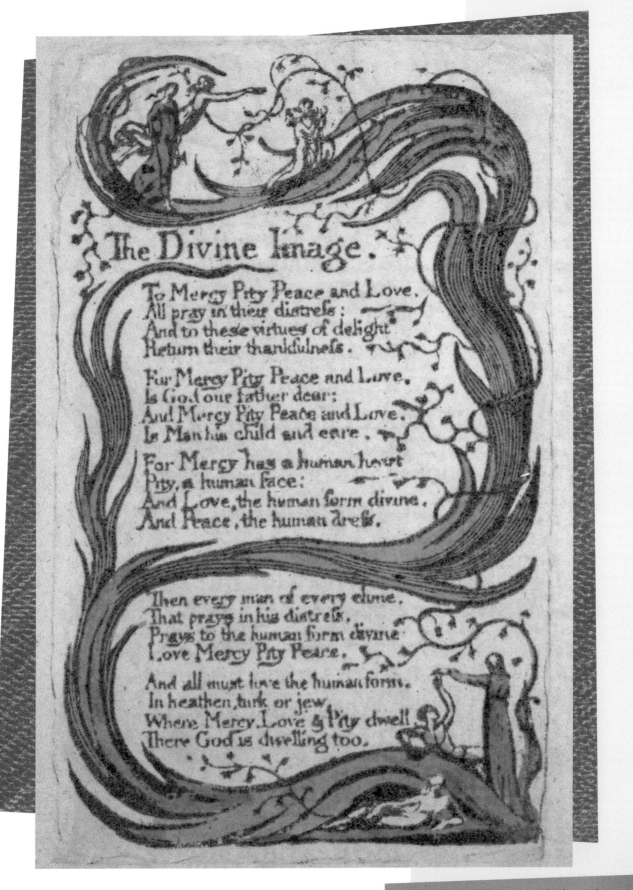

The Divine Image.

To Mercy Pity Peace and Love,
All pray in their distress:
And to these virtues of delight
Return their thankfulness.

For Mercy Pity Peace and Love,
Is God our father dear:
And Mercy Pity Peace and Love,
Is Man his child and care.

For Mercy has a human heart
Pity, a human face:
And Love, the human form divine,
And Peace, the human dress.

Then every man of every clime,
That prays in his distress,
Prays to the human form divine
Love Mercy Pity Peace.

And all must love the human form,
In heathen, turk or jew,
Where Mercy, Love & Pity dwell
There God is dwelling too.

unknown artist André Derain, Maurice de Vlaminck, and Georges Braque. He had a knack for matching up artists and writers, and would often commission them to work together. In the early 1900s, Kahnweiler published books on such artists as Picasso, Juan Gris, and Vlaminck.

The Twentieth Century

During the twentieth century, artists began to transform the traditional book into a conceptual, highly original artwork. In 1913, painter Vasily Kandinsky produced *Klange*, a book of his poems illustrated with his woodcuts. As both artist and writer, he controlled the entire production of the book.

Throughout the 1930s, many avant-garde artists and surrealists began to use photomontage, collage, and assemblage as a way to produce books. German artist Max Ernst came up with his own version of a book without words. In 1934, he produced *A Week of Kindness,* a five-part novel composed of collages from engravings.

Also in the thirties, Italian Bruno Munari began creating books with no text, using abstract collages, cutouts, and folded sheets of paper. In the forties, he created *Libro Illegible,* which

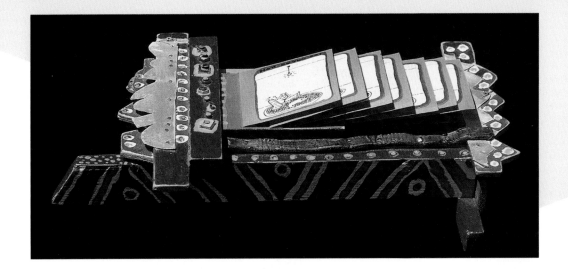

literally means "illegible book." The work was a bound collection of hand-stitched and cut pages of different textures and colors.

Groundbreaking artist Marcel Duchamp experimented with many three-dimensional forms of art. In a work called *The Green Box,* he used green "suede" paper to cover a box containing various scraps of paper. On these bits of paper he wrote notes and thoughts about the making of one of his large sculptures. *The Green Box* was a kind of creative scrapbook about his creative process. This work became the model for other books or works with text that are not specifically "bound" in a book. In 1941, Duchamp created *Box in a Valise (Boîte en Valise),* a portable gallery or portfolio representing his larger works of art.

Henri Matisse also explored a personal approach to merging the visual and the verbal. In 1947, he created *Jazz,* a large unbound book of 146 pages with twenty color plates. Using his words as visual elements, Matisse wrote out the text by hand. He also incorporated torn and cut-paper images for a personal, sensual statement about his art.

During the fifties, many artists around the world explored the book as an art form. Artists in Denmark, Belgium, and

1–4 This book, although contemporary and colorful in style, is in some ways reminiscent of ancient primitive books. Early wooden tablets or slates, stacked and bound in unusual ways, were often more sculptural in nature. In this work, the artist explores a different way of compiling book pages and an unusual choice of materials.

Janet Pyle, *How Do You Do?* 1988. Wood, aluminum, steel, brass, leather, acrylic paint, paper, colored pencil, 15 x 10 ¹/₂ x 3 ¹/₂" (38.1 x 26.7 x 8.9 cm).

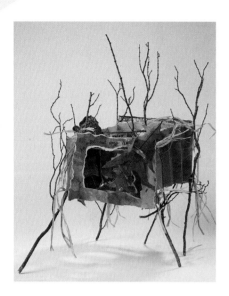

1–5 The artist was inspired to create this work after reading a quote on nature by Henri Matisse. Utilizing the format of a tunnel book, she developed the theme by using natural objects along with quotes written throughout the "pages."

Ellen McMillan, *Art.. Nature.. Matisse*, 1994. Watercolor paper, leaves, branches, mixed media, 9 x 19 x 13" (22.8 x 48 x 33 cm).

Holland; French Lettrists; the Concrete poets in Brazil, Germany, and France; and performance artists were discovering the book as a means of communicating their ideas. Asger Jorn and Jean Dubuffet produced books incorporating their own text with woodcuts adorning the margins. Dieter Roth, from Iceland, was influenced by Munari's work and became known for his elaborate hand cuts and die cuts. He gave great consideration to the structure and format of his books rather than creating pages for purely visual or verbal placement. Roth founded his own press in 1957.

Beginning in the 1960s, George Maciunas started an international collaborative movement called the Fluxus. Artists created surrealist collages, cards, booklets, and many other items that were sometimes put together in boxes. Many of the publications of the Fluxus movement were influenced by the Dada and Futurist artists, who worked toward artistic freedom and social change.

Book arts took off in the United States about this same time, in keeping with the experimentation of the 1960s. Two mass-produced book works of this time were *Ray Gun Poems* by Claes Oldenburg and Allan Kaprow's *Assemblage, Environments and Happenings.* By taking advantage of advancements in technology, these artists produced books more economically and reached a wider audience.

Ed Ruscha's *Twenty-Six Gasoline Stations* is filled with photographic images facing a blank page—a book without words. In 1967, Andy Warhol published his *Andy Warhol Index (Book).* This brightly colored pop-up book of colorful images and games opened further possibilities of the book as art.

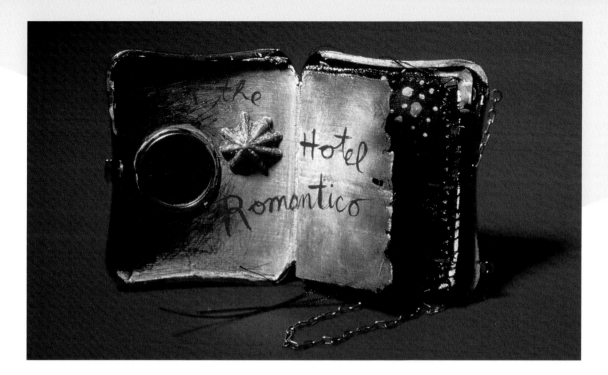

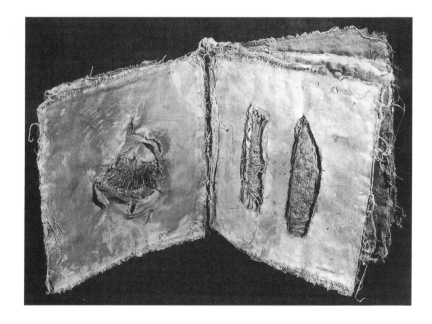

1–6 "Mobile, compact, and transportable" are three words that define common aspects of a book. This artist has come up with a new twist on these parameters.

Sas Colby, *At the Hotel Romantico*, 1994. Silver purse, fabric, paint, found objects, mixed media, 3 5/$_8$ x 6 1/$_2$" (9.2 x 16.6 cm). Photograph by Phillip Kagan.

1–7 Book artists throughout history have explored a broad range of possible media when creating pages for their books. In this case, the artist has selected a frayed-edge cloth, giving her book a soft, flexible, "touch me" appearance.

Sylvia Glass, *Book of Memory*, 1992. Layered muslin, found objects, acrylic, encaustic, 7 x 13 1/$_2$" (17.8 x 34 cm).

By the 1970s, conceptual artists were using the artist's book as a means of expressing and distributing political and social views around the world. Artists such as Sol LeWitt and John Cage saw the book as more than a vehicle of mass reproduction. They saw the potential to investigate and express views about art beyond the boundaries of wall pieces,

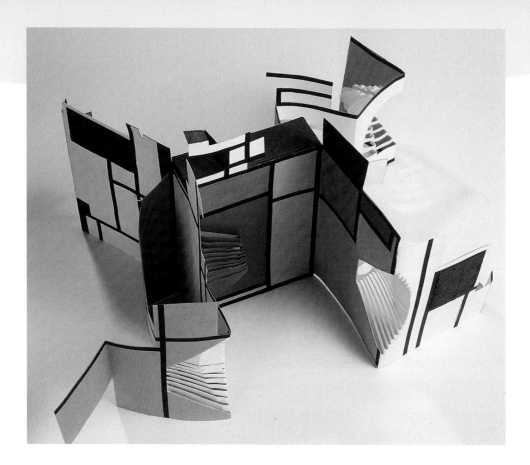

1–8 Artists often find inspiration from artists in the past. In this artwork, the artist expresses a personal connection to an artist that shares her Dutch heritage— Piet Mondrian. Taking the accordion format to an extreme, this book folds out in four directions, yet can be folded down flat and housed in a slipcase.
Ellen McMillan, *Dutch Connections: Mondrian-McMillan*, 1994. Watercolor paper, tape, mixed media, 9 x 22 x 16" (22.8 x 55.9 x 40.6 cm).

performances, and sculptures. The book provided a new forum for artistic expression in a more inventive, flexible, personalized way.

In 1993, Cage completed *The First Meeting of the Satie Society*. This work, a cracked glass and metal valise, held seven books with prints, collages, and drawings by Jasper Johns, Sol LeWitt, Robert Rauschenberg, Cage himself, and others. The valise also contained a folder with poems based on quotes by Henry David Thoreau and James Joyce and artist Marcel Duchamp. This work became a symbol of the freedom of the artist.

Many artists began to expand their bookmaking into sculptural works, large-scale books, and installation pieces. Some works were ambitious attempts at scale and complex physical arrangements incorporating video recorders and computers. Suddenly, there was a fine line between sculptural

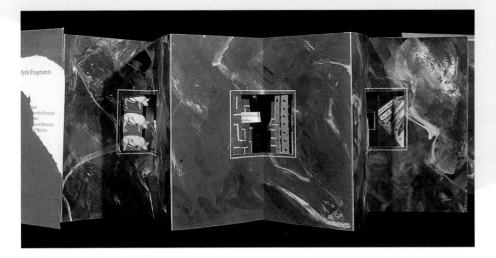

1–9 Books can be created from sculptural materials or, in this case, can imitate materials used in sculpture. The stone or marble texture of the paper gives this work a heavy, solid presence.

Carol Barton, *Myth Fragments*, 1987. Acrylic, photocopier, mixed media, 5 1/4 x 7 1/8 x 48" extended (13.3 x 18 x 122 cm).

works and sculptural books. Although the artist's book is nontraditional in format and structure, an artist might move so far away from the book format that the work no longer resembles the form and purpose of a book. In sculptural works, the relationship between the viewer and the work differs greatly from the reading and viewing experience associated with books.

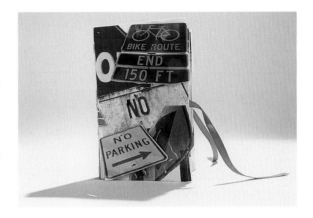

As interest in the production and the craft side of book arts continued in the late twentieth century, Keith Smith's texts on book production found a vast audience. His books stress structure as being of foremost importance in how a book is "read." The structure helps guide the reader's reaction to the book. Smith's approach to bookmaking contributed information helpful to future book artists.

1–10 Themes and ideas for sculptural books can stem from everyday life. Inspired by ordinary road signs, this artist developed her theme by photographing signs along roadways in her neighborhood. Separating them into different categories, the artist created a photo-collage on each page enhanced with hand-drawn images.

Marcy Connor (student), *Untitled*, 1996. Photograph collage, mat board, ribbon, 5 1/2 x 7" (14 x 17.8 cm).

Throughout three centuries, the artist's book has accommodated many different artistic styles and motives. It has been used as a means of expressing ideas, showing off artists' works, and communicating social and political ideas. Although it has taken on many forms throughout history, the artist's book remains a true forum for artistic expression.

2 Inspiration

Sometimes an artist's book can be traditional in format and made in multiple copies. Another type of artist's book, called a *sculptural book,* is one of a kind, meaning that only one has been made. A sculptural book is not meant to be reproduced and read like a typical book. It is meant to be viewed as sculpture, as a stand-alone work of art, whether it is open or closed.

How does a sculptural book take shape? Although the form of the artwork is different from a traditional painting or drawing, the process of creating the work is much the same. Consider how you create a piece of art. Do you start with an idea, a concept, or a notion that evolves into the final creation? Perhaps you just begin by doodling or by working

2–1 A traditional book cover clearly conveys the topic and purpose of a book. The meaning of a sculptural book, however, may not be readily understood. The sheer mystery of the artist's intent can add intrigue to the work. What does this mean? What is the artist trying to say?

Sas Colby, *Book in a Box,* 1994. Collaged book in wire box with stones, mixed media, 5 x 6 ¹/₂ x 4" (12.7 x 16.5 x 10 cm). Photograph by Phillip Kagan.

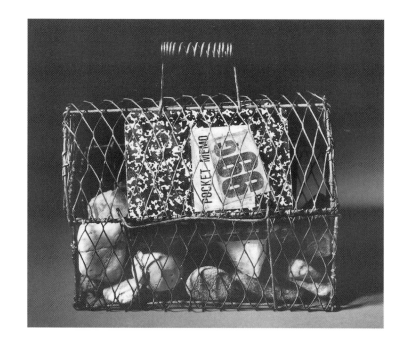

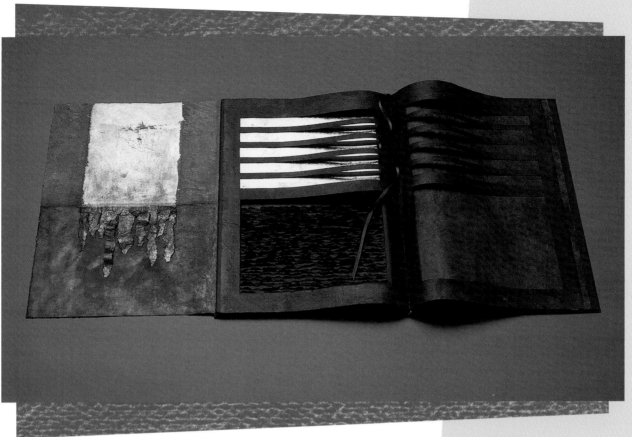

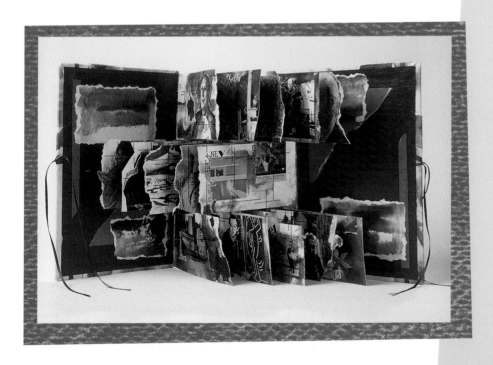

2–2 While writers use words to express ideas, artists use color, texture, and line to express a thought or experience.

Pia Pizzo, *Night in Venezia,* 1988. Mixed media, 30 x 63" (76.2 x 160 cm). Photograph by Gregory Page.

2–3 Important people or historic events can be a source of exciting themes. Famous artists provided the inspiration for this crisscross book. (See chapter 8 on how to make one.) Each "flap" or "page" is devoted to a particular artist and explores the artist's style and works.

Ellen McMillan, *Artist Alphabet Book,* 1993. Watercolor paper, colored inks, magazine and Xerox collage, mixed media, 8 x 12 x 20" (20.3 x 30.5 x 50.8 cm).

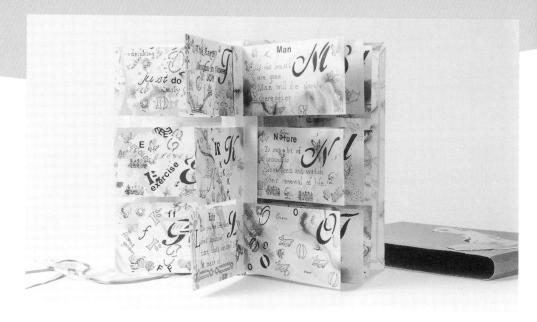

2–4 In this variation of a crisscross book (see chapter 8), the artist created an alphabet book to express her feelings about the earth, humanity, and nature. On each mini-page are words and phrases that begin with or feature a letter of the alphabet.
Donna G. Benjamin, *Planet Earth*, 1995. Watercolor paper, watercolors, markers, 8 x 13" (20.3 x 33 cm).

clay or other materials until an idea or concept develops. As your idea takes shape, you look for ways to achieve a sense of continuity, which lends coherence and interest to the final work. Once you find motivation or inspiration in an idea, then develop this idea in a unique format, you can produce a very personally satisfying piece of work.

Ideas for sculptural books can spring up at any time, in any place. Nature presents an abundance of ideas. The land, the sea, animals, or plants can open up a multitude of subjects, themes, and ideas to motivate the artist. Perhaps you want to portray the beauty of nature, or you may want to show how people have exploited the natural world.

Social issues and current events are frequently the motivation for great works. Inspiration may be just as close as the daily newspaper. By focusing on a political or social theme, you can create a work that makes a significant statement.

Personal issues, such as families, or personal expressions about love, hope, responsibility, and compassion may motivate the artist. Frustration, anger, or sadness can also provide themes for a sculptural book.

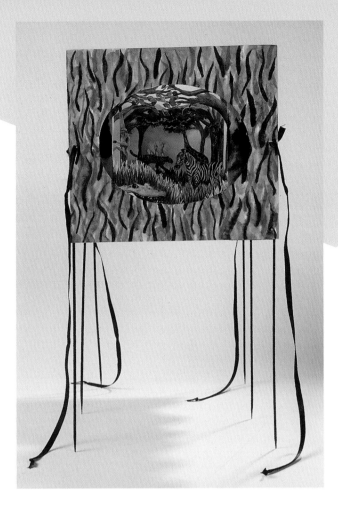

2–5 Nature is a popular theme among artists who are sensitive to the natural beauty in this world. In this tunnel book on stilts (see chapter 13), the viewer is drawn into a three-dimensional jungle scene.

June Reichenbach, *Jungle Travels,* 1992. Watercolor paper, bamboo skewers, ribbon, mixed media, 8 $^1/_2$ x 16 x 18" (21.6 x 40.6 x 45.7 cm).

2–6 To make this personal, emotional statement, the artist etched letters about a painful family situation onto glass sheets. These sheets were then broken and placed in glass boxes.

Theodore Clausen, *Two Letters: To Him, To Her,* 1992. Glass, edition of two, two boxes each measuring 10 x 10 x 12" (25.4 x 25.4 x 30.5 cm).

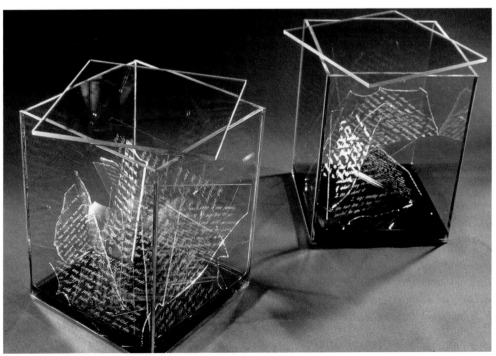

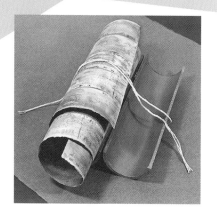

2–7 History provides a different kind of inspiration in this work, which is based on a historical form. Scrolls are one of the oldest formats for recording information.

Anne Siberell, *The Scribe's Obsession.* Scroll and casing. From the collection of the National Museum of Women in the Arts, Washington, D.C.

History provides another rich source of themes and events that an artist can develop. A work might describe certain events that hold a special meaning to you. Or, you might focus on a significant figure in history.

Once you have chosen a topic or theme, the process of developing this idea begins. A broad theme may need to be narrowed so that you can focus on conveying the desired statement or feeling. Next, you must gather the appropriate materials and resources. To construct a sculptural book, the artist must work within the framework of what is physically and technically possible. Many times, the materials that are on hand play a big part in the inspiration for the theme.

The next step is to organize the materials and resources, to consider how to best present them. Once these beginning

2–8 Reading a book is often like passing through a doorway into a new world. This artist has taken that feeling and expressed it visually.

Lillian A. Bell, *Interior for Don Quixote: the obscure by the still more obscure*, 1993. Scanned Xerox, mixed media, 14 x 25 x 12" (35.5 x 63.5 x 30.5 cm). Photograph by Doreen L. Wynja.

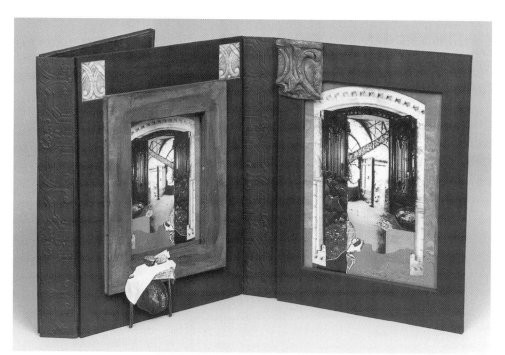

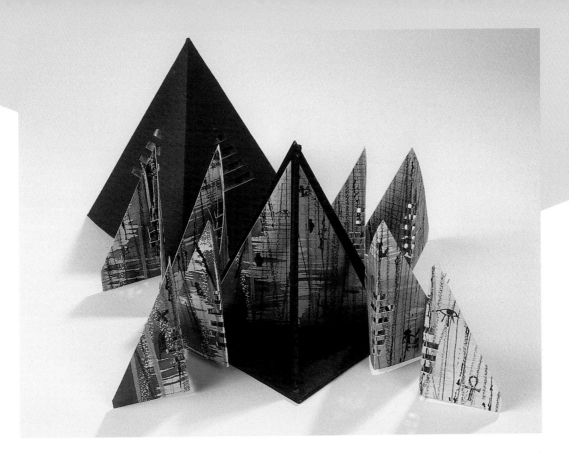

steps have been thought through, you can then carry out the theme throughout the book and create a truly individual work with meaning.

The projects contained in the next chapters provide you with new directions to follow in creating imaginative and expressive forms of art. By building on these ideas and instructions, you can produce new and exciting artworks—perhaps something you have never attempted to create. As you master each new skill and technique, you may surprise yourself as to what you can create.

Challenge yourself! Many times artists go beyond what is presented to them. They take it to the limit; they explore the unlimited possibilities of the medium. What they create is truly a statement about how far one can go with an idea taken to its most innovative extreme. Let the works shown in this book motivate and inspire you to investigate more diverse avenues of expression.

2–9 Making a connection to timeless works of art can inspire an artist to explore a period of history in a new format.
Toby Schwait, *Egypt Revisited*, 1992. Mixed media, 12 x 18" (30.5 x 45.7 cm).

3 Creating a Journal

When you create your own book from cover to cover, when you have control of every page, the result is a very individual, personalized piece of work. The work can become a scrapbook of ideas, a collection of thoughts to be developed, examined, and explored. Like a sketchbook or journal, the work becomes something to revisit, the meaning of the pages something to muse over.

Begin with the idea of creating a place to record your thoughts, feelings, and ideas as you go about your daily routine. Picture an artistic journal of memories, bits of everyday life. You could concentrate on one theme, or create a format for a random collection of drawings and memoirs.

Once you have a central idea, you will need to make choices about how to construct your book. How will you use this book? Do you want something portable to carry around? Will it be kept in a special place, to be used only when you need to express private thoughts? Your answers to these questions will impact how you will create and bind the book. Here are some things to think about.

Hand-bound Books

Many customized bookbinding techniques can be adapted to fit your personal concept of a sketchbook. Many times, the binding technique plays a major role in the whole concept of the book.

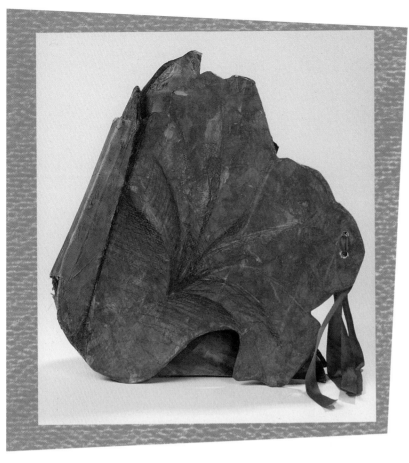

3–1 The cover for this personal sketchbook began with mat board cut in the shape of a flower, then covered with tissue paper collage and enhanced with colored pencil. Extra mat board and tissue paper were added to conceal the spiral binding.

Dana Trott (student), *Flower Book, exterior,* 1995. Mat board, tissue paper collage and assorted papers, 13 x 11" (33 x 27.9 cm).

3–2 Sketchbook pages are made from different types and textures of papers with special meaning to the artist. These include letters from friends, personal notes, school papers, and drawings of her sister.

Dana Trott (student), *Flower Book, interior,* 1995. Mat board, tissue paper collage and assorted papers, 13 x 11" (33 x 27.9 cm).

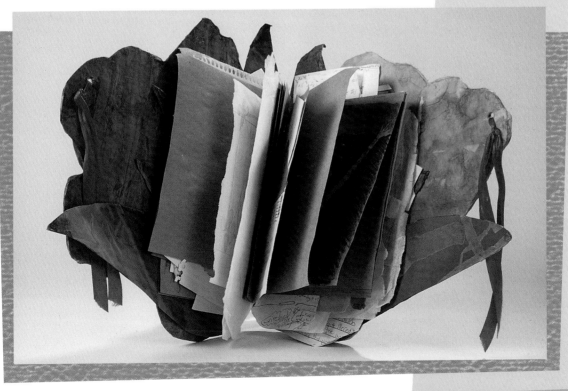

3–3 This book was bound by stringing wires through hand-punched holes. To coordinate with the book's theme of "color," the artist attached a paintbrush to the outside binding.
Christina Nelson (student), *Color Book,* 1995. Mat board, metal wire, paintbrush, 8 x 8" (20.3 x 20.3 cm).

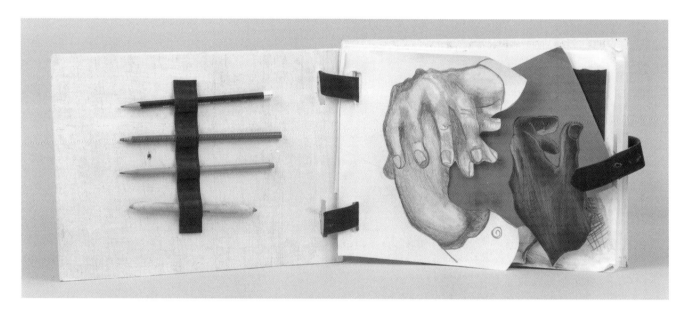

3–4 Pages were cut to add interest to the drawings of hands in this personal sketchbook. The artist bound the book with a leather belt and attached a leather strap to the inside cover to hold drawing materials.
Marcus Bickler (student), *Hands, Interior,* 1996. Wood, leather, paper, 13 x 10" (33 x 25.4 cm).

Hand-binding can allow for more versatility—giving you more control and more choices about what you can include in the book. Some papers—depending on thickness, texture, or size—may not be suitable for machine-binding due to the constraints and limitations of the machine itself.

Hand-binding lets you select binding materials that relate to the theme or "feel" of the book. You also have more creative options, such as binding the book on more than one side, or creating several different binding locations throughout the book. When considering methods and materials, keep in mind that the binding provides the foundation and support of the book. You want to choose something that not only looks good but will hold up structurally.

Machine-bound Books

Many artists prefer to construct their personal sketchbook using machine-bound techniques. Perhaps you are aiming for a simple presentation, or perhaps you want a more technical look. Maybe you are looking for a faster method of binding your pages. Whatever the reason, many exciting pieces have been produced using a mechanical method of binding.

Several different types of binding machines can be purchased at office and business supply stores or through catalogs. They range from very simple, basic binding to more complex and versatile binding. The most common binding machine will punch holes and bind pages with plastic rings that are usually available in different sizes and colors. Some binding machines are also designed to punch and bind using wire spiral binders. Wire binders are not as readily available at stores and may need to be ordered.

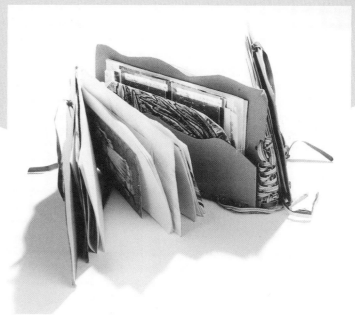

3–5 This personal sketchbook is bound in two different places. The artist chose to fasten the pages with ribbons as the binding material.
Rebecca Stires (student), *Untitled Sketchbook,* 1995. Paper, ribbon, mixed media, 7 x 11 x 3" (17.7 x 27.9 x 7.6 cm).

You may run into some technical restrictions to machine binding. There is a limit to the quantity of papers that can be bound, and there can be difficulties with the texture or thickness of your paper. Odd shapes can also present a problem.

You also want to consider how the binding looks, how it fits with your vision for your book. Some artists feel that the clean, technical look of mechanical binding enhances the

3–6 Artists may begin with a commercial bound book and manipulate and create their own personal version of a sketchbook. Materials that follow a theme can be attached throughout the entire book.
Jacob Feinstein (student), *Assortment of personal sketchbooks*, 1996.

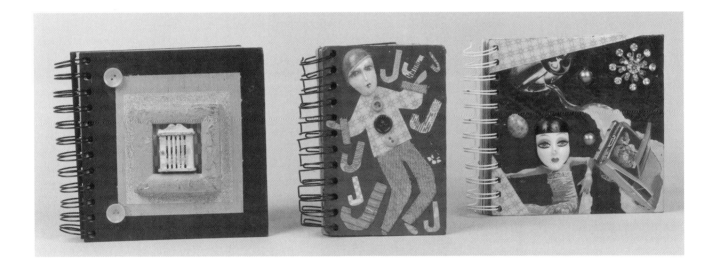

presentation of their book. Some choose to bind their books mechanically and later disguise the binding. Others mechanically bind several separate sets of papers and incorporate them into a larger book format.

Another consideration is the time element involved. Hand-bound methods can be very time-consuming. The relative speed of machine binding can save you a lot of time, time you

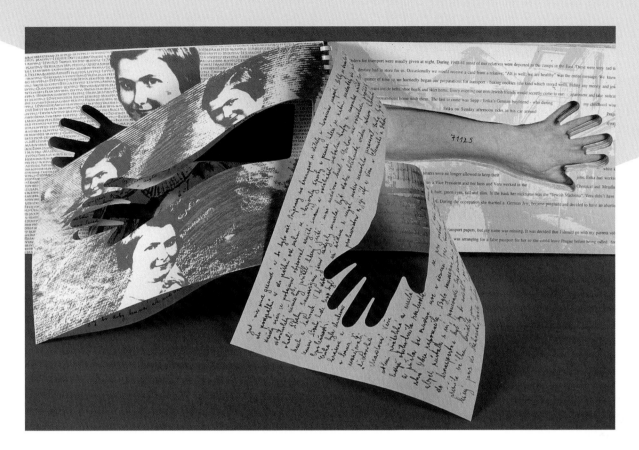

might rather spend on other creative aspects of your bookmaking.

Selecting the Papers

Selecting the papers for your pages can be an exciting experience in itself. Choose papers that have meaning. Many times the papers you select will inspire ideas about what to place on those pages. Keep in mind that you do not have to stay within the confines of "paper."

Anything that can be written or drawn on can be used. Personal school papers, letters from friends, envelopes, photographs, magazine pages, paper or plastic bags, packing material, calendar pages, phone book pages, and pages from old books are just a few examples of the range of choices.

3–7 In an intriguing combination, this artist used traditional spiral binding for a very nontraditional work. Her approach combines the look of a handwritten journal with sculptural and graphic elements. Tatana Kellner, *71125: Fifty Years of Silence*, 1992. Silkscreen, cast handmade paper, 12 x 40" (30.5 × 101.6 cm).

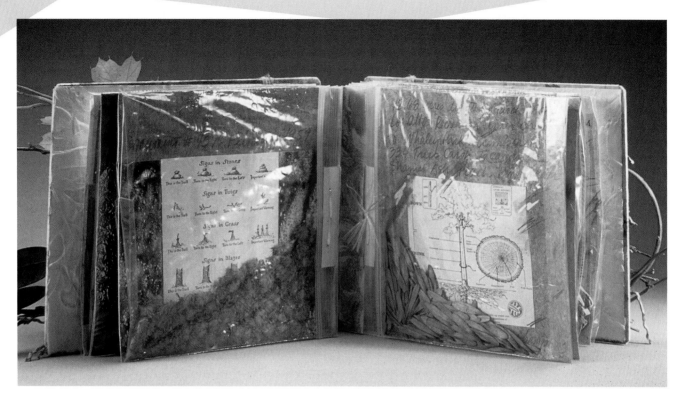

3–8 The unique "pages" of this book contain natural objects and descriptions of Long Beach City Parks. The "Baggie Book" form is original and copyrighted by the artist.
Sue Ann Robinson, *Park Art,* 1987. Unique, mixed-media artist's book, accordion spine, zip-lock pages, found objects with text and maps, 7 x 26 x 10" (17.7 x 66 x 25.4 cm). Photograph by Victoria Damrel.

More traditional art papers include tissue paper collage, tracing paper, watercolor paper, construction paper, or corrugated cardboard. You could also choose acetate, mat board, handmade paper, or specialty papers. Whatever you decide, your choices will be unique to you and will hopefully provide a creative base for your ideas.

Creating the Cover

You have heard the expression "You can't judge a book by its cover." However, the cover does convey an important first impression of your work. Your choice of cover presentation is an invitation into your book, a first look at what to expect in the contents. Sometimes the cover introduces the theme or idea that is conveyed in your book.

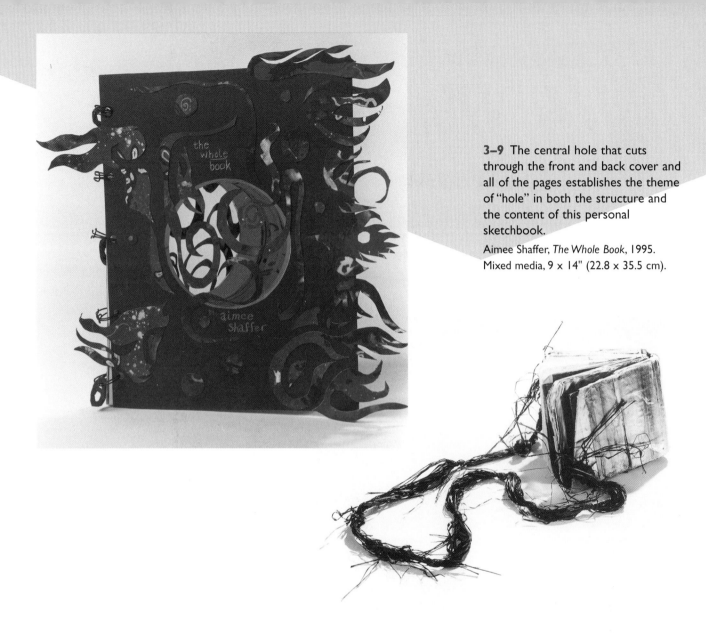

3–9 The central hole that cuts through the front and back cover and all of the pages establishes the theme of "hole" in both the structure and the content of this personal sketchbook.
Aimee Shaffer, *The Whole Book*, 1995. Mixed media, 9 x 14" (22.8 x 35.5 cm).

In contemplating the design for the cover, consider the purpose and use of the book. For example, if you will be taking it to different locations for drawing, you will need a sturdy, user-friendly cover. A book that remains in a special place at home, as a place to record private thoughts, can accommodate more attachments or embellishments on the cover. The basic steps in making a book cover are explained in chapter six. With this background knowledge, the pathway to ideas for more artistic book covers is open.

3–10 This artist had already constructed large personal sketchbooks to carry around during the day. Now she wanted a smaller version to carry to the senior prom. For this book, she used a variety of papers for the interior, a metallic paper for the cover, and raffia for the shoulder strap.
Rebecca Stires (student), *Prom Book*, 1994. Mixed media, 6 x 6" (15.2 x 15.2 cm).

4 What Do I Need?

Although sculptural bookmaking doesn't require expensive tools and equipment, some basics are needed for the bookmaking process. Most of the supplies can be obtained inexpensively at art supply stores or from catalogs.

Materials

Paper

Many beautiful papers are available in art supply stores. Some are handmade and wonderfully textured. Some may be pale and elegant, while others may be bold and brilliant. When making your selections for sculptural books, keep in mind that you need a heavyweight paper for structural stability. Usually this means a minimum of 120 lb. paper. If the paper is not strong enough, your cutouts and add-ons will not be self-supporting and the books will take on a flimsy appearance. At the other extreme, if the paper is too thick, folding will be a problem and the book may be hard to open and close. Ideal choices include 130 lb. watercolor paper, tag board, and card stock.

While the pages of a book are typically made from paper, a creative choice of materials can produce successful results. Imagine a book with pages made from heavy gauge metal, a book with wooden pages, or a book made from Plexiglas tinted with inks and markers. The possibilities are endless— the sky is the limit!

4–1 (Right) Three rows of hand-cut spirals flutter and create the sound of the wind in the trees when the book is opened and closed. The book is self-supporting when fully extended because of the heavy printmaking paper used to create it. If a lightweight paper had been used, the book would not stand when opened.
Sheril Cunning, *Incantation for the Night of the Giant Radish*, 1985. BFK heavyweight printmaking paper, paint, 11 x 20" (27.9 x 50.8 cm).

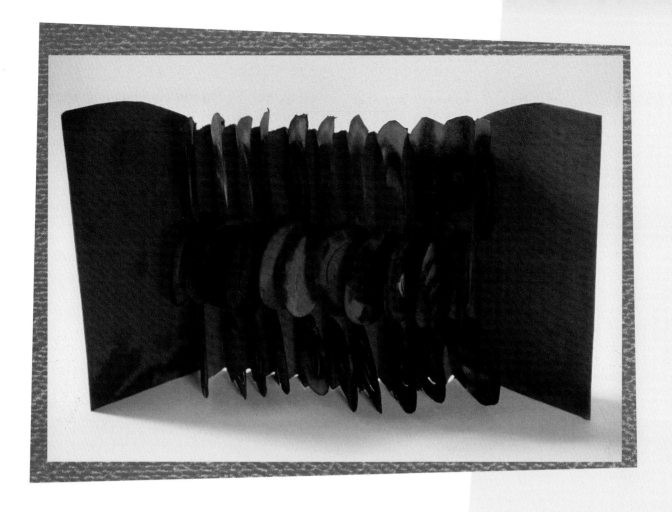

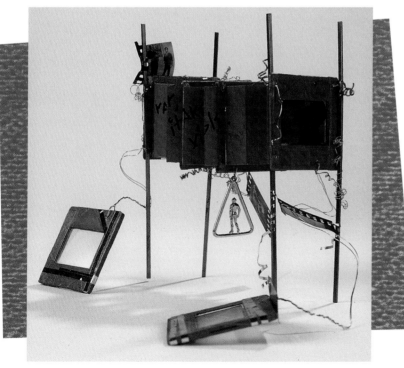

4–2 This miniature variation of the tunnel book illustrates the use of nontraditional materials in bookmaking. Slide mounts are used as the pages of the book. The artist invites the viewer to look through a magnifying glass glued into a slide mount placed in front of the artwork.

Ellen McMillan, *Make It Visible,* 1993. Slide mounts, negatives, wire, metal rods, mixed media, 2 x 6 x 5" (5 x 15.2 x 12.7 cm).

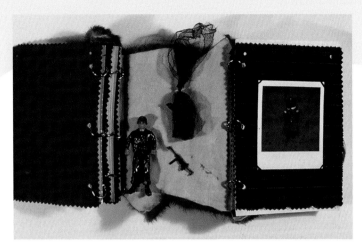

4–3 This book expresses the artist's interest in the bear as a goddess archetype. Although the content of this book is deeply personal to the artist, the use of alternative materials to construct the book illustrates how ordinary materials can make a book extraordinary.
Claudia Nix, *Bruin, or The Grand Bear Hunt*, 1985. Fabric, paper, found objects, leather, 11 x 17 x 2" (28 x 43 x 5 cm).

Construction paper, metallic paper, or color-fast paper can be used for collaging or as end papers on the book covers. (Your paper supplier should have information about colored papers that will not fade.) End papers—sheets of paper that are glued to the insides of cover boards—add a finishing touch to a book's interior. Fabric, bits of mirror, reflective materials, metal, sandpaper, and other nontraditional materials can also be used as end papers, or even as the pages themselves.

Wet Media

To add color and design to the pages, use a variety of wet media. An ideal combination is color-fast fabric dye (which will not fade) on watercolor paper. Dyes come in a wide range of intense colors that penetrate the fibers of the paper and provide a rich, deep color. Other media can also be effective, such as drawing inks, watercolors, or watered-down paints (tempera or acrylic). Some artists on a limited budget have even used food coloring to lay down color on their papers!

Drawing Media

Colored pencils, crayons, markers, and metallic paint pens are good choices for decorating and drawing designs on the papers. To add texture and variety to the paper, try using more than one type of drawing media.

Cover Boards

For the covers of your book, almost any strong, stiff board can be used. Two-ply chipboard works well, or you can glue two pieces of mat board together. (See chapter six, page 38, for instructions.) For the most professional-looking cover, use three-ply chipboard. Although it is not a first choice,

corrugated cardboard can be used as an alternative to chipboard if you have a limited budget.

Glue

For preparing the covers and gluing the books together, you can use white school glue. For a faster-drying glue, spray adhesive is excellent; however, it is not recommended for school use because of its toxicity. Tacky glue is superior for its quick-sticking abilities, and can be used when a fast tack is desired.

Tools

When you start the projects in Part 2, at the beginning of each chapter you will find a list of materials you'll need, such as paper (often specific sizes), special pens, and dyes.

In addition, we recommend that you collect ahead of time some basic tools that are needed for most bookmaking projects. These are listed in the box at right and will not be listed again in every chapter. Basic tools include implements for drawing and measuring, a variety of paintbrushes, and cutting tools. The cutting tools suggested for bookmaking include a craft knife with a #11 blade (X-acto knife) for cutting watercolor paper and other lightweight papers, and a utility knife for cutting chipboard, mat board, or cardboard.

Equipment

When you create a personal journal or other types of sculptural books, a commercial binding machine may be preferable to hand-binding. Plastic spiral or wire binding machines can be purchased at most office supply stores. A paper cutter with a 24" blade saves time when you need to cut the pages of the books. No other specialized equipment is necessary for the sculptural bookmaking processes described in this book.

Tool Box

For decorating paper
- paintbrushes, assortment of sizes
- sponge in a container with water
- spray bottle
- rubber gloves

For drawing and measuring
- pencil
- eraser
- ruler
- compass

For cutting
- scissors
- craft knife, blades
- cutting mat (could be thick cardboard)
- paper cutter

Additional options
- one-hole paper punch
- clothespins for holding glued papers together while drying

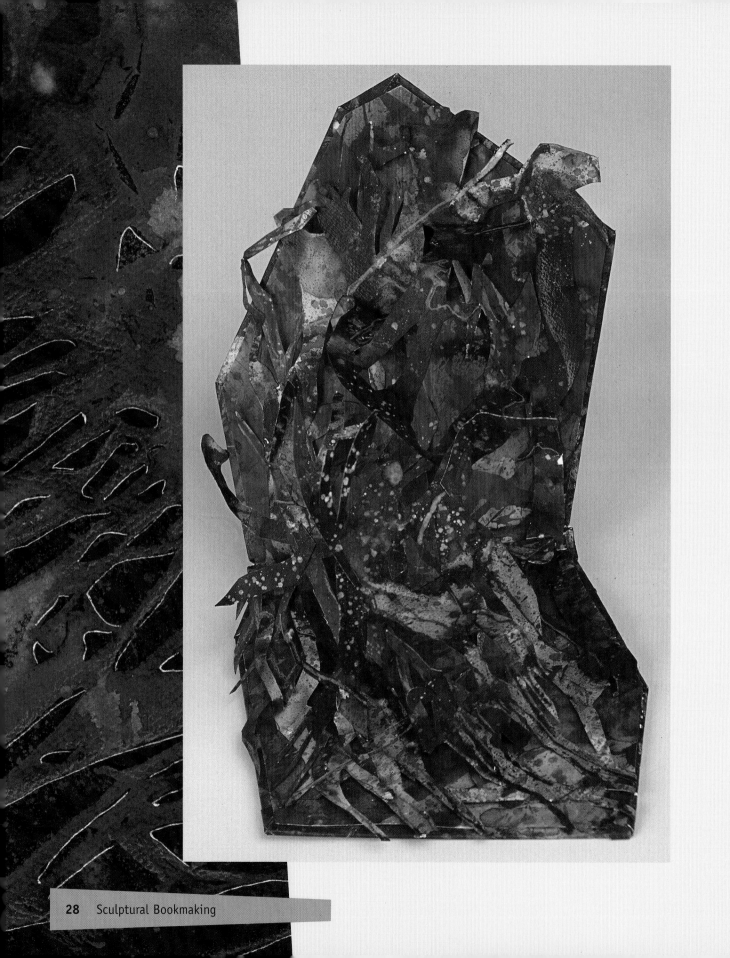

Part Two: Making Sculptural Books

P–2 The artist combined two completely different, contrasting pop-up pieces to create this unusually-shaped 90-degreee pop-up book.

Ann Ayers, *Enigma Personified*. Mixed media, 9 x 12" (22.9 x 30.5 cm).

5 Decorating Paper

Materials

- 130 lb. watercolor paper
- squeeze bottle or eye dropper
- fabric dyes
- drawing inks
- colored pencils
- colored markers
- gold or silver paint pens
- bleach
- tools listed in chapter four

optional
- drinking straws
- cardboard scraps
- spray bottle

Other than choosing a theme, probably the most important decision in bookmaking is how to decorate or treat the paper. There are many traditional ways to transform the paper, such as marbling, pulled paste methods, block printing, and paper batik. In this book, we focus on two particularly beautiful methods of "making paper."

In this case, "making paper" does not mean the process of creating a sheet of paper from pulp, but rather refers to the decorating process. Layered inks and dyes can create a wonderful feeling of depth. When you also apply drawing tools—such as markers, colored pencils, pen and ink—that feeling of depth is strengthened.

Rubber stamps or eraser stamps can be used to add another textural layer to dyed paper, or the stamping can be a decorating medium in itself. The look and feel of your finished book depends on the colors and the methods you choose. Your early choices are an essential step, and deserve some time and thoughtful consideration.

Layered Inks and Dyes

The layering process combines a variety of techniques and produces papers that are rich in color and depth. While the process can be lengthy, it is well worth the time it takes to decorate the paper. When completed, the papers could stand alone as art before the bookmaking even begins. So, gather up your supplies, and let's get started!

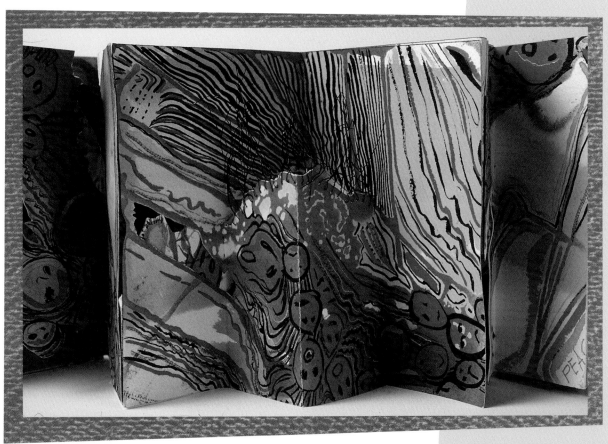

5–1 The work of this artist illustrates the process of decorating paper. First the artist dripped dyes on the paper to create a unique webbing of lines and color. He then used colored pencils, markers, and metallic pens to emphasize and enhance linear and contour lines he saw in the pattern of the dyes.

bruce gambill, *Bringing Back the '60's*, 1994. Watercolor paper and inks, 6 x 4 ¹/₂ x 24" (15.2 x 11.4 x 61 cm).

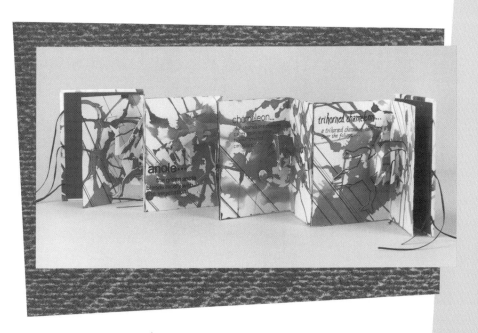

5–2 Using nature as the motivation for this accordion book, the artist narrowed his theme to focus on different types of lizards.

bruce gambill, *Lizards*, 1993. Watercolor paper, colored inks, mixed media, 4 ¹/₂ x 6 x 24" (11.4 x 15.2 x 61 cm).

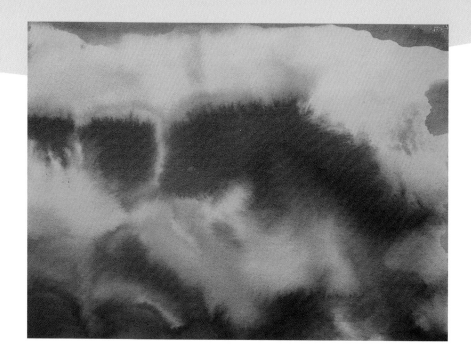

5–3 Layer one. Use inks or dyes to lay down a layer of color. After wetting the paper, add the dyes and allow the colors to bleed into each other. This becomes the background layer.

Procedure

1 The first step is to lay down a background of color. Color—not design—is important at this point. Before you begin, put on rubber gloves to protect your hands from the dyes and inks. Then use a water-soaked sponge to thoroughly wet the paper on one side.

Use a squeeze bottle or dropper to apply the dyes or inks. Or, apply the dyes with a brush or sponge to cover large areas. Because the dyes are wet and the paper is wet, the colors will tend to run and bleed into each other. This effect is quite appealing if the colors are compatible. However, if complementary colors are placed side by side, the bleeding will produce a muddy brown or gray. Keep in mind that the colors look intense when they are wet but will lighten when dry.

Allow the paper to dry thoroughly, and then repeat the process on the other side. The thickness of the paper does not allow colors from one side to bleed through to the other side.

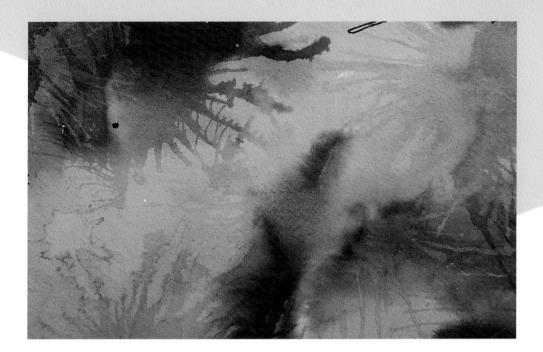

5–4 **Layer two.** When the background is dry, use inks or dyes to add a second layer of color to the paper. The transparency of the dyes lets the previous layer show through.

You could choose harmonious colors for both sides, or contrasting colors. You might try warm colors versus cool colors, complementary hues on opposite sides, or any number of combinations.

❷ When both sides of the paper are dry, add another layer of color with the dyes or inks. Because the paper is dry, not wet, as in the first step, the dyes will not spread on their own. Concentrate on shapes and design as you direct the flow of color.

First, apply the dyes with a dropper or a brush. Then "move" the dye around the page with a paintbrush. To add some interesting effects, use a straw to blow the dye around, or use the edges of a stiff piece of cardboard to disperse the dye. Splattering the dyes or using a stiff brush to create small specks can also add variety to the layering process.

You don't need to stop with one layer. You can add many layers, using a different technique each time. The transparency of the dyes will reveal a bit of each color beneath, adding a feeling of depth to the colors and shapes. Diluted bleach can be used sparingly to lighten dark areas or to add touches of white to the layered dyes. The bleach should be mixed with water (two parts bleach to one part water) and can be applied with a brush or spray bottle.

3 For your last layer, use markers, colored pencils, paint pens, and other drawing media to enhance the designs created in the first few layers of dyes. Select a fine-tip marker and outline some of the shapes. This technique can bring out the beauty of the designs. Colored pencils can be used to add shapes, lines, or patterns to the paper.

5–5 Layer three. Use colored pencils or markers to outline some of the shapes created in the second layer of inks and dyes. This will define areas and create a feeling of depth.

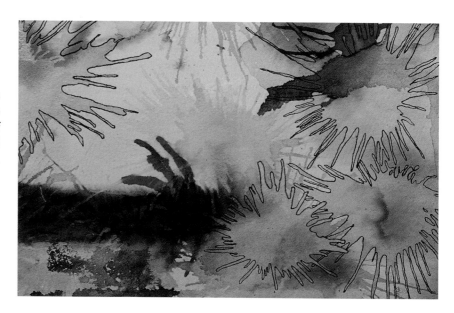

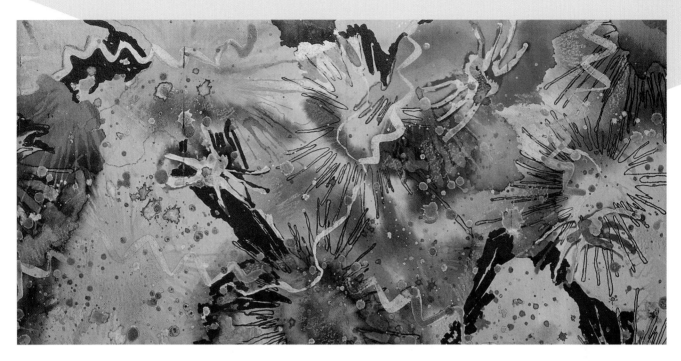

5–6 A completed sheet of paper. Colored pencils, markers, and metallic pens are used to enhance the layers created in the decorating process.

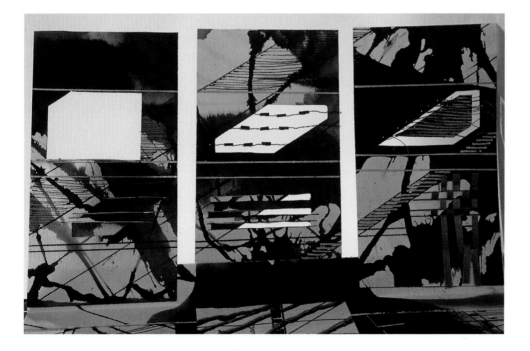

5–7 Cutting into the individual pages and adding beads and wires adds interest to the pages and helps create a more sculptural effect.

bruce gambill, *Icon from the Inner-City of My Soul,* detail, 1991. Mixed media, 13 x 8 x 20" (33 x 20.3 x 50.8 cm).

Using Rubber Stamps

An alternate method of "making paper" is to use rubber stamps or eraser stamps to create designs and patterns on the background color.

Procedure

1 Use a permanent marker to draw a design on one side of the eraser. Take a sharp craft knife and outline the design. Cut into the eraser at a depth of about 1/4". Remove the excess eraser, leaving only the raised design.

2 Tempera paint can be used as a stamping medium. Brush paint onto the raised design on the eraser. Then stamp the eraser onto the watercolor paper to create a painted design. Try using additional colors and stamps to create a richly textured pattern.

5–8 Create a pattern or a freeform design using the eraser stamp in combination with other stamping or designing techniques. Found objects and commercial stamps also can be used to create designs on the paper.

Tips and Variations

Commercially made rubber stamps can also be used as stamps, as well as found objects dipped into paint. Keep in mind that the paper should be treated as a whole. Do not just work at the center of the paper. If you are decorating more than one piece of paper for a particular book, lay the papers side by side and treat the papers as a single sheet. Whatever you do to one, do to the others. This way, you are making holistic design decisions early on. When the papers are cut up, they will more naturally go together.

Once the paper is decorated, your foundation is ready. You are ready to start constructing your book. In the pages that follow, you will find a wide range of styles and techniques to try. Templates are provided to help you cut your paper to size. Use leftover pieces to decorate your project or save them for a later project. You might decide to cut holes or openings into pages to add a spatial feeling to the book. You might add beads or wires, or weave threads, ribbons, or other materials through the openings. Whatever you choose, you are on your way to creating your own unique sculptural book.

6 Making Book Covers

Because it is the first invitation to the piece, the cover is one of the most important parts of a sculptural book. The cover should entice the viewer to go further, to open the book, to look inside.

The cover may be the first thing you see on a sculptural book, but it is the last thing you make in the bookmaking process. By making the cover last, you can adjust the cover to fit the book, rather than the other way around. Nonetheless, it is best to consider the cover when planning the book as a whole. If you are decorating watercolor paper, as described in chapter five, and want the cover to match the interior, you will need to make enough paper for both. For each book project that follows, a cutting template for the cover is provided. Use those templates as a reference when you plan your book cover.

The procedures described in this chapter provide a foundation for the book projects that follow. We recommend that you learn the process of making covers now to familiarize yourself with the basics, then refer back to this chapter as needed.

The Basics of Making Covers

The cover is basically made up of two parts: the paper and the board. Selection of the paper is the first step in cover preparation. The paper can be the same type that the pages are made of, or it can be of a contrasting texture or fiber

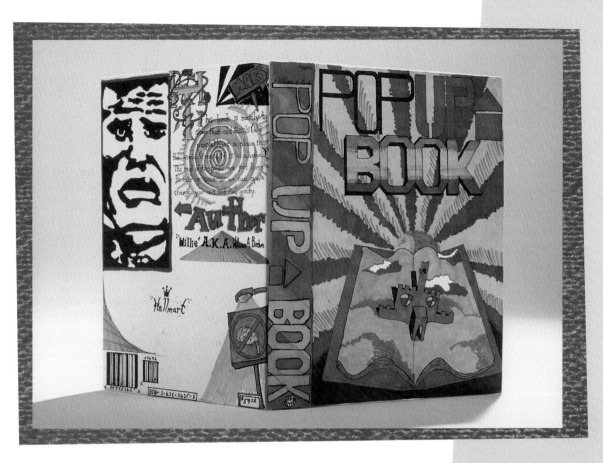

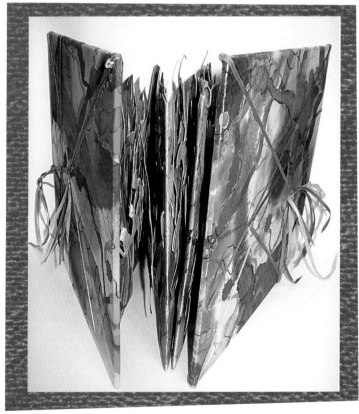

6–1 Using a "sixties" theme, this student artist created a colorful and interesting cover that gives the viewer a suggestion of what is inside this layered sculptural book.

Billy Boehm (student), *Pop-Up Book,* cover, 1996. Colored pencil and marker on tag board, 9 x 7 x 1 ¹/₂" (22.8 x 17.8 x 3.8 cm).

6–2 This accordion book, seen from the back, is an example of a book without a spine. The book is constructed as a freestanding sculpture supported by sturdy covers on each end, and opens up to a length of 64 inches. (To make an accordion book, see chapter 7.)

Student work, 1992. Dyes and marker on watercolor paper, 8 x 64" (20.3 x 162.5 cm) open, 8 x 8" (20.3 x 20.3 cm) closed.

6–3 The detail on the cover of this book invites the viewer to further explore this piece. How does it pique your interest about what's inside?
Patricia Taback, *Stuff*, detail, 1993. Mixed media, 8 x 13" (20.3 x 33 cm).

content. Either way, take time to consider how the cover presentation and the pages can be unified in style, theme, or approach.

Once you have chosen the paper, decorate or paint it to coordinate with the inside pages. Dyes, paints, or other types of media can be used to color the paper, as described in chapter five. Additional drawing media can further enhance the paper before it is cut for the cover.

For the board used for the core of the cover, double or triple thick chipboard is ideal. While a double thick board creates a very adequate cover that is easy to cut and manipulate, a triple thickness is a bit more professional in final appearance. Single, double, and triple thick chipboard is relatively inexpensive for those on a limited budget; however, you can also glue cardboard or mat board together instead of purchasing the board. In some instances, corrugated cardboard will suffice as an adequate cover board.

As a rule of thumb, a cover should extend beyond the dimensions of the pages by $1/4$" on all sides. The exception to this would be a book that is designed to "stand" on its bottom side. Its cover would need to be flush with the book pages along the bottom edge so that the book won't tip over when displayed.

There are two basic types of covers: a cover without a spine and a cover with a spine. A spine is a piece of cardboard between the covers that provides support for the back of the book. Most commercially made hardcover books have a spine. Both types are easy to assemble.

Making a Cover without a Spine

Measuring and Cutting

Select a piece of chipboard or cardboard that is $1/2$" longer and $1/2$" wider than the interior pages. For example, if your book pages measure 6 x 8", your cover board will measure 6 $1/2$ x 8 $1/2$". Use a craft knife or a paper cutter to cut two boards to size (for front and back covers).

Select a piece of paper for the covers, preferably one that has already been decorated. This paper should measure 3" longer and 3" wider than each cover board. For example, if a cover board measures 6 $1/2$ x 8 $1/2$", the cover paper should measure 9 $1/2$ x 11 $1/2$". Cut two papers (for front and back covers).

Placing and Gluing

For each cover, the procedure is as follows. Turn the cover paper so that the decorated side is face-down. Center the board so that there is an even margin all around. Use a pen or pencil to draw around the cardboard so that placement will be accurate when gluing the board.

Remove the board and completely coat one side with a thin layer of white glue. You can make a "spreader" from a scrap piece of board or cardboard to push the glue evenly over the cover board. A good spreader size is about 3 x 5", enough to provide good coverage when spreading the glue. However, any size large enough for you to grip with your fingers will do. An alternative to using a spreader would be to use a 2-inch or

Materials
- board for the cover
- decorated paper
- white glue
- scrap mat or chipboard for use as a spreader
- masking tape
- tools listed in chapter four

3-inch brush to apply the glue. Whichever method you choose, make sure that you spread the glue evenly on the cover boards.

Lay the glued side back down on the cover paper, using the penciled outline as a placement guide. Weight down the cardboard by placing several books or other heavy objects on top of the glued cover. Wait until the glue is dry, preferably overnight. If the board is not weighted down, it has a tendency to warp. Sometimes the paper bubbles, sometimes the board curves—both are usually undesirable effects.

Finishing Up

1 When the glue is dry, you can finish the cover. For heavyweight papers, the best way to proceed is to cut off the corners. This keeps the corners from becoming too bulky. Make diagonal cuts, as shown, that come within $1/8"$ of the corners of the chipboard.

2 Select a flap and fold it over the chipboard. For heavy-weight papers, fold it back and forth several times to create a sharp, flexible crease. Spread white glue evenly and completely on the flap and then press it to the board. Follow the same procedure for the remaining three flaps. If desired, use masking tape to secure the flaps until they are dry. To prevent warping, you can again weight down the glued areas with heavy objects.

3 If the cover paper is relatively lightweight and flexible, the board can be covered a different way. Fold the corners of the paper over, as close to the corners of the board as possible. Don't cut them off. Instead, glue the corners onto the board, then fold the flaps over and glue down onto the board. Do this

on all sides until the board is "wrapped" in the cover paper. Weight down until dry.

End papers—papers glued to the inside of the cover to cover up the chipboard—may be attached now or when you assemble the book. This cover is now ready to be attached to interior pages. Ways to do this are discussed in the following chapters.

Making a Cover with a Spine

Measuring and Cutting

To make a cover with a spine, cut three pieces of chipboard. To determine what sizes to cut, measure the pages of your book and add $1/2$" to the length and $1/2$" to the width. For example, if your book pages measure 6 x 8", your front and back cover boards will measure 6 $1/2$ x 8 $1/2$". This will give you $1/4$" allowance on all four sides of the page. To figure out the width of the spine, stack your completed pages and measure the stack. Add $1/4$" and this will be the width of the spine. The length of the spine should match the covers. In this example, if the book pages stack to 1" high, the spine for this book would be 1 $1/4$ x 8 $1/2$".

Measure and cut a piece of decorated paper for the cover. Determine the size of this piece by laying the cover pieces and the spine side by side. Leave $1/4$" between the cover pieces and the spine, then add 2" on all sides all the way around the book.

Assembling

1 Place the decorated side of the cover sheet face-down. Arrange the chipboard pieces as shown on page 44, leaving a $1/4$" space between the chipboard pieces. (This space is needed

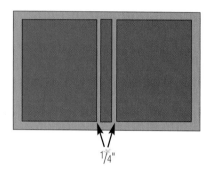

so that the cover can easily bend into a book shape.) Use a pencil to outline where the pieces will be glued.

Using a scrap piece of chipboard, spread a thin coating of white glue on one side of the chipboard. Place the glued chipboard on the cover paper inside the penciled outlines. Weight everything down with books and allow to dry overnight.

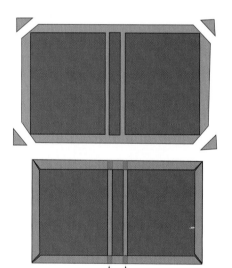

2 When the piece is dry, cut the corners as shown. Fold over the flaps and glue them to the inside of the chipboard. If you are using heavyweight paper, fold the crease back and forth to make the fold flexible before gluing. To make the crease sharper, try pressing down on the crease with the handle of a pair of scissors. Use masking tape, if necessary, to hold the flaps in place until dry.

When gluing the flaps to the $1/4$" space between the chipboard pieces, press down very hard, making a groove where the space is (see arrows). If you do not do this, the book may not be flexible enough to open and close properly.

3 For the end papers, select a piece of colored or decorated paper. Cut it approximately 1" smaller in dimension than the entire cover (including spine). Glue it to the inside of the cover to hide the chipboard. Force the paper into the grooves of the cover. Crease and fold the grooved sections to make the cover fold.

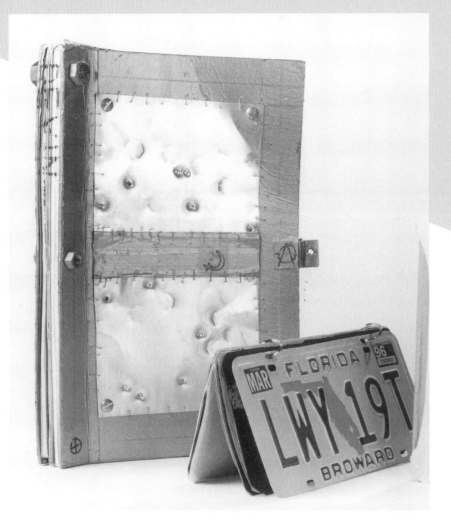

6–4 Covers can also be made from untraditional materials. The large, solid-looking sketchbook on the left incorporates bolts, staples, metallic tape, and pieces of metal. The binding includes tabs for a padlock. The smaller book has a more whimsical feeling. The cover is constructed from a license plate; the hand-punched pages are held together with metal rings.
Devin Frizzell and Staisha Grosch (students), *Personal sketchbooks*, 1996.

To attach pages to this type of cover, you have a couple of options. In most of the projects that follow, the interior pages are joined together as a unit. The unit can be attached to the covers boards by gluing the first and last pages directly on top of the end papers. In some cases, the front and back pages can serve as end papers themselves. Another option is to add flaps to the pages, then glue the flaps to the cover. In this case, you might want to glue pages to the cover board before adding the end papers, which can then cover both the cover boards and the flaps.

7 Accordion Books

Materials

- one decorated sheet of 22 x 30" watercolor paper, 130 lb. weight
- a variety of colored paper
- 2- or 3-ply chipboard or mat board that is doubled
- white glue
- tools listed in chapter four

Imagine an ordinary book that is rectangular or square in format—yet, when opened, it has wonderfully long, connected pages flowing from cover to cover. These continuous pages might tell a story, indicate rhythm and movement, or simply stand on their own as a sculptural unit.

The most familiar, and perhaps the simplest, of book formats is the accordion book, also known as a concertina, zig-zag, or fanfold book. While basic in shape and construction, the accordion book can be very versatile in appearance.

The accordion book is a good choice when you are working with a theme. Pop-ups and cutouts enhance the book and provide a "pathway" or link between pages. When both sides of the pages are used, the book becomes an in-the-round sculptural piece, inviting the viewer to inspect the book from all sides.

The creation of an accordion book is relatively easy. The hard part is deciding on a theme (if any), and deciding how the cutouts and pop-up pieces will enhance the book. Pages

7–1 When opened, the accordion book becomes an intricate and intriguing in-the-round sculptural piece. Ellen McMillan, *Color Life*, 1991. Mixed media, 8 x 8 x 48" (20.3 x 20.3 x 122 cm).

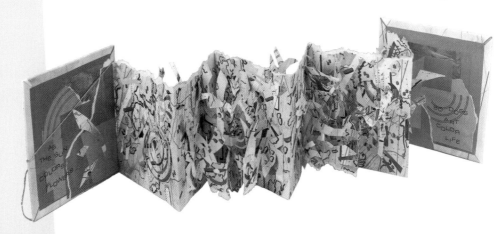

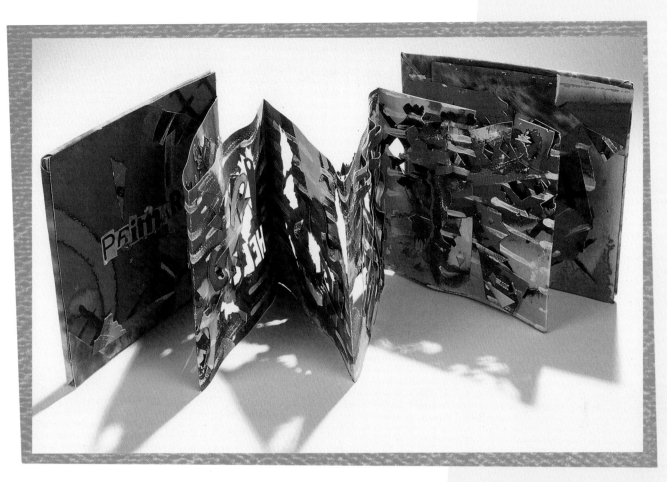

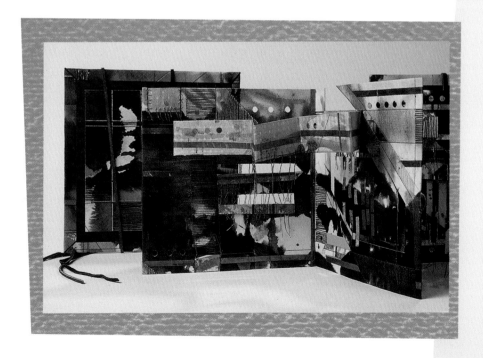

7–2 This accordion book was created using a primary color scheme. The primary color dyes interacted on the watercolor paper to create the secondary colors and a richly colored sculptural book.

Jeff McCartney, *Primary*, 1990. Watercolor paper, 9 1/4 x 9 1/2 x 37" (23.5 x 24 x 94 cm).

7–3 On these pages, bold lines and rectangular cutout pieces contrast with organic shapes formed by the dyes. Strong vertical and horizontal themes make this a very powerful composition.

bruce gambill, *City of the Self*, 1991. Mixed media, 9 x 9 x 36" (23 x 23 x 91.4 cm).

can be rectangular or square, large or small. The flexibility of the design lends itself to all kinds of possibilities.

Procedure

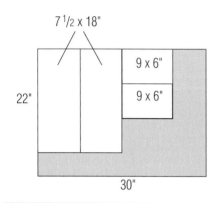

1 Start with a sheet of decorated watercolor paper (see chapter five for details on decorating paper). Use this sheet to cut both the cover and the pages of the accordion book (see template, left). Measure and cut two 7 1/2"-wide strips for your pages, and two 9 x 6" pieces for the covers. Set the cover pieces aside for now.

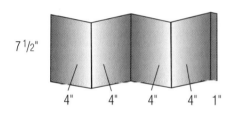

2 Select one of the strips. Cut this strip to a length of 17". Starting at one end, measure out 4" sections along the strip. There will be four sections with a 1" strip left on the end. Accordion-fold (or fanfold) on these lines as shown.

3 Take the second strip and cut it to a length of 18". Start at one end by marking a 1" section, then measure out 4" sections. This will leave a 1" section at the other end. Accordion-fold along the marked lines.

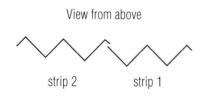

View from above

strip 2 strip 1

4 To create a long fanfold strip, join the two strips together. Overlap the extra tab on the second strip with the unfolded edge of the first strip, as shown. Apply glue and allow it to dry.

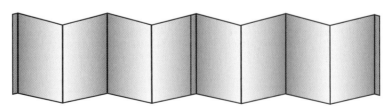

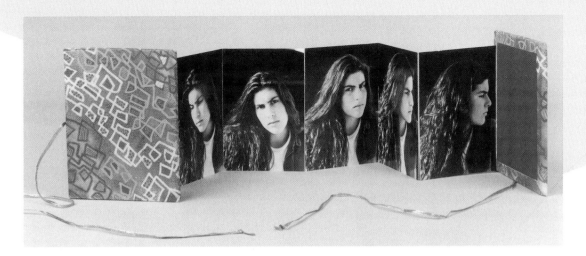

5 To create the front and back covers, first cut two 8 x 4 ¹/₂" pieces of chipboard. Examine your two 9 x 6" pieces of decorated watercolor paper and choose which side will be best for the cover. Place this side face-down. Spread glue on the chipboard and center it on the watercolor paper with an even margin on all sides. Place several books on top to weight down the paper and chipboard while drying. Repeat this process for the other cover. (See chapter six for detailed instructions on making the cover.)

Complete the covers by mitering the corners and gluing the edges. Attach the accordion pages to the inside of the covers by gluing the 1" strip on each end to one of the covered chipboards. Make sure that the bottom of the pages are even with the bottom of the covers or the book will not be easy to display. There will an extra margin at the top, as seen in figure 7–2.

7–4 The pages of this very personal accordion book are photographs of the artist's daughter. Photos of her face are on the pages "facing" forward, and photos of the back of her head appear on the back side of the pages.

Patricia Taback, *Rachael, Rachael,* 1994. Photo and mixed media, 5 x 7 x 40" (12.7 x 17.8 x 101.6 cm).

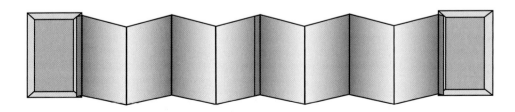

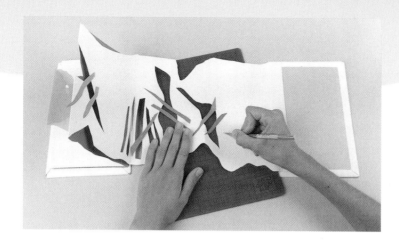

6 Use a craft knife to cut shapes from the pages. The shapes can follow the designs on the paper or can be random "holes." The tops and bottoms of the paper can be altered; however, be careful not to cut too much off the bottom edges or the pages will not be able to support the book. Some of the shapes need not be removed entirely, but may be cut on three sides and then folded. The cutout piece then becomes an added element on the reverse side.

7 From the remaining pieces of watercolor paper, create pop-ups to add between the accordion folds. To make these, fold strips of paper and cut out a symmetrical or asymmetrical shape. Include folded tabs on the ends for glue. Additional scraps may be added to these pieces to make them more intricate.

Attach each strip by gluing the tabs onto two adjacent accordion pages. Check that the pages will still fold properly without bunching up. Because this is an in-the-round sculptural book, consider the appearance of both sides of the book.

The accordion book is designed to be displayed opened, with the pages spread out. However, another visually appealing option is to tie monofilament line to each of the pages and the cover and suspend the book vertically as a hanging piece of art.

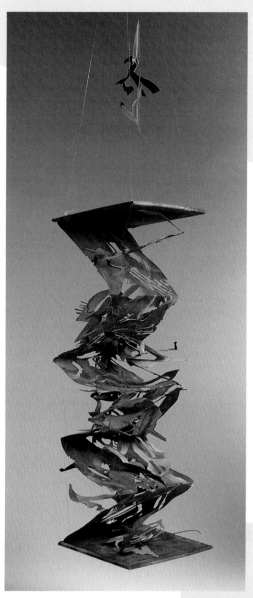

7–5 Monofilament lines strung through the sides and covers of this accordion book convert it into a hanging sculptural piece. Ann Ayers, *Just a Figment,* 1992. Watercolor paper with dyes, 6 x 6 x 48" (20.3 x 20.3 x 122 cm).

7–6 This accordion book can be displayed open on a table or sculpture stand or hung by strings attached on its sides. By using silk flowers as part of the book, the artist has added interest to the piece. Kimberly Little, *Strong Knots with Loose Ties,* 1996. Watercolor paper, 6 x 26" (15.2 x 66 cm).

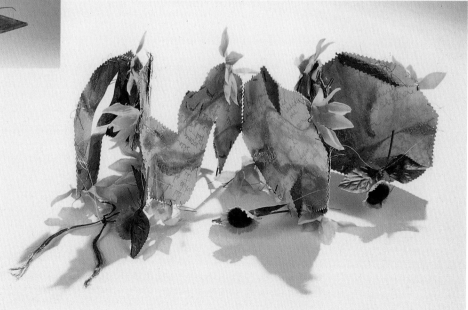

8 Crisscross Books

Materials

- two pieces of 22 x 30" decorated watercolor paper, 130 lb. weight
- construction paper or fadeless paper in your choice of colors
- 2- or 3-ply chipboard or mat board that is doubled
- white glue
- tools listed in chapter four

The crisscross book, also known as the flag or flap book, is so named because its pages cross back and forth over each other when the book is pulled open. At first glance, the book looks like a children's mix-and-match book, with each "page" made up of three separate smaller pages. Like a traditional book, the pages, which are usually rectangular, can be turned. But, if you gently pull the covers out to stretch the accordion spine, the top and bottom page sections go in one direction, while the middle page sections go in the opposite direction. The book can be displayed as an in-the-round sculptural piece or fully opened to reveal the crisscross pages.

Following a theme for this type of book is very easy because each page section presents a blank space on which to convey the theme. The letters of the alphabet, famous artists, animals, fish—anything with a series of images on the same topic—are all subjects that would work well with this type of book. Photographs, photo transfers, and collaged images are great solutions to the creation of individual pages.

Although the crisscross book looks complex, it is simply a series of pages that are pasted onto an accordion (fanfolded) spine. This section will explain the basics of the crisscross book and provide the necessary directions to get you started.

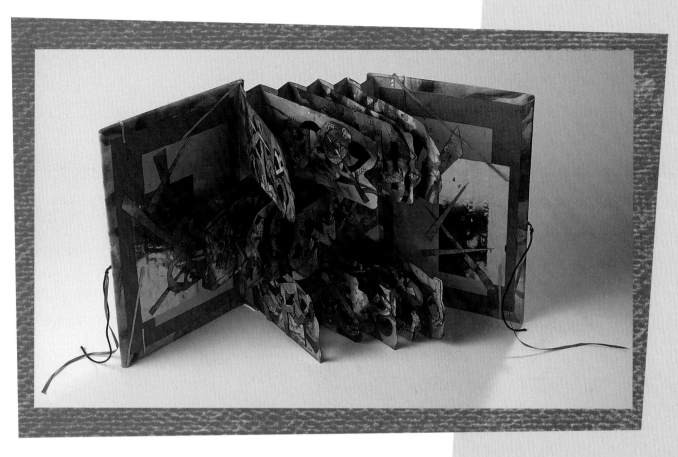

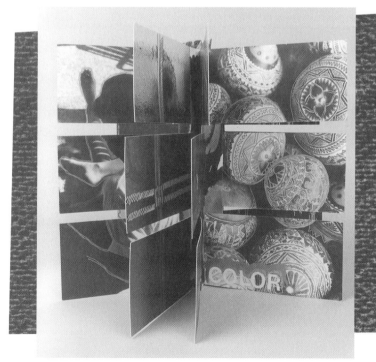

8–1 When first opened, a crisscross book looks like a traditional book even though each page separates into three sections. However, when the covers are pulled apart and the accordion spines are extended (as shown), the pages "crisscross" over each other, allowing patterns and designs to merge.

Ann Ayers, *A-B-C*, 1992. Mixed media, 8 x 13" (20.3 x 33 cm).

8–2 When the covers of the completed crisscross book are joined together back to back, the individual pages can be viewed as an in-the-round sculpture.

Patricia Taback, *Stuff*, 1993. Photos and mixed media, 8 x 13" (20.3 x 33 cm).

Procedure

1 Start with a sheet of decorated watercolor paper (see chapter five). Measure and cut fifteen 3 1/4 x 6 1/2" page sections from the decorated paper (see template, left). Now design the pages according to your chosen theme. You may want to cut out holes, reshape the edges, add on other pieces, or do some collage. If you are going to have a reoccurring pattern throughout the book, you will need to figure out how the pattern will flow on the pages. Think through the design of the book before you start gluing it all together.

15 pages: 3 1/4 x 6 1/2"

22"

10 x 12" (spine)

scrap

30"

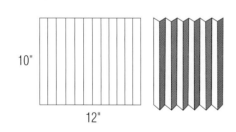

10"

12"

2 From the same piece of watercolor paper, cut a 10 x 12" section for the spine. Along the 12" side, measure and mark off 1" segments. Do the same along the bottom, and draw vertical lines to guide your folds. Fanfold along each marked line.

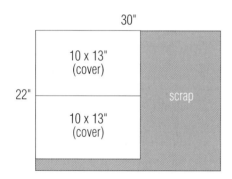

30"

10 x 13" (cover)

22"

scrap

10 x 13" (cover)

3 From your second piece of decorated watercolor paper, cut two 10 x 13" pieces for your front and back covers (see template). Then cut two 7 x 10" pieces from the chipboard or mat board. Cover the chipboard with the watercolor paper (see directions in chapter six).

4 Glue the folded ends of the accordion spine to the cover pieces. Make sure that the bottom of the accordion spine is flush with the bottom of the cover. This will give the book a solid base so that it can stand up on end.

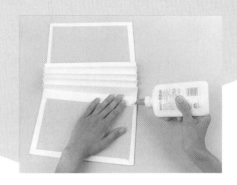

5 Once the spine is attached to the cover, you can glue on end papers. You can use some of your decorated watercolor paper or, for contrast or added interest, use a totally different color or textured paper. End papers should be about $1/2$" smaller on each side than the dimensions of the chipboard. For example, if the chipboard is 7 x 10" the end papers should be 6 $1/2$ x 9 $1/2$". When glued into place, the end paper will hide the ends of the spine. Weight down the covers until the end papers are dry.

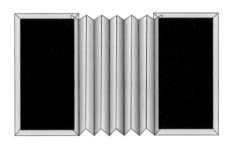

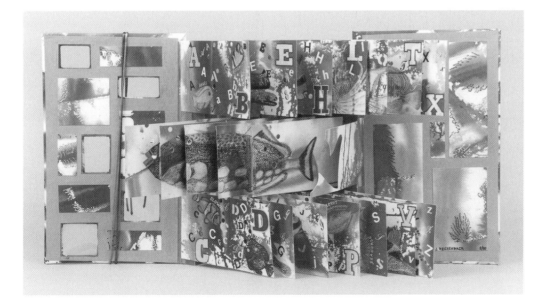

8–3 In this crisscross book, individual pages contain drawings of fish. When the book is fully extended, the center pages depict a large fish drawing.

June Reichenbach, *Alphabet Fish*, 1990. Mixed media, 8 $1/2$ x 13" (21.6 x 33 cm).

6 Now you can attach the decorated page sections to the spine. Start with the first accordion fold, which will be your first "page" (composed of three page sections). Glue the top page section on the **front** of the fold, facing to the **right**. Keep this section flush with the top of the spine.

Glue the bottom section in the same way—on the **front** of the fold, facing to the **right**. Make sure to glue the bottom section flush with the bottom of the accordion spine. Otherwise, the book might tip over when displayed.

Glue the middle section on the **back** of the fold, facing to the **left**. Center it between the top and bottom page sections. You should have about 1/8" of space between the sections. This will allow the pages to crisscross easily when opened.

7 Continue on to the next accordion fold, and follow the same procedure. Keep going until the accordion spine is filled

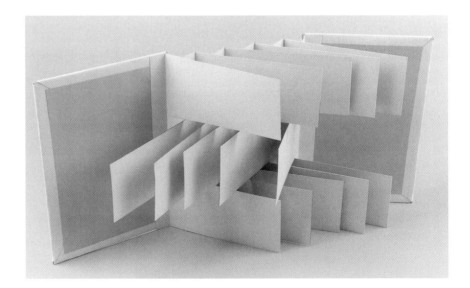

8–4 Intricate designs and cuttings can make each page unique.

Heather Bobbing (student), *Detail of Unfinished Book Pages*, 1992. Mixed media.

with the pages. There will be ten sections facing to the right and five sections facing to the left.

The book can be displayed in two distinctly different ways. You can stand it on end, like a traditional book, with the accordion extended and the pages crossed (as in figure 8–1). Or, you can pull the covers around until they touch back to back, then fasten them together (see figure 8–2). This causes the book pages to fan out in a circular format. Either way, this type of sculptural book will certainly draw attention when it is displayed and viewed.

9 Radial Books

Materials

- two pieces of 22 x 30" decorated watercolor paper, 130 lb. weight
- construction paper or fadeless paper in your choice of colors
- 2- or 3-ply chipboard or mat board that is doubled
- white glue
- tools listed in chapter four

As its name implies, a radial book is based on a round format. This type of sculptural book is a dramatic departure in format from traditional books. The radial book is a visual surprise. Closed, it is a triangular-shaped book. Opened halfway, it becomes a half circle. When fully opened, it is a large, round book with peaks and valleys and many dimensions. Some artists have fashioned structures—such as tree branches or sticks tied together in a tripod shape—to hold the radial book in an open and free-flowing position, allowing the viewer to see the book on all sides. The use of pop-ups and add-on pieces can add interest to the book and give it a feeling of openness.

The procedure for making a radial book is similar to that of an accordion book. It essentially calls for two identical geometric shapes that are cut out, fanfolded, and then joined together. Holes are cut into the pages to open the structure, and pieces are added to create more three-dimensionality. This type of book is suited for almost any type of material—watercolor paper, tag board, posterboard, construction paper, heavyweight paper, cardboard, or even nontraditional book materials such as metal or acetate. Materials that cannot be folded are hinged together with wire or string. Whatever the media, the radial book is an in-the-round visual delight.

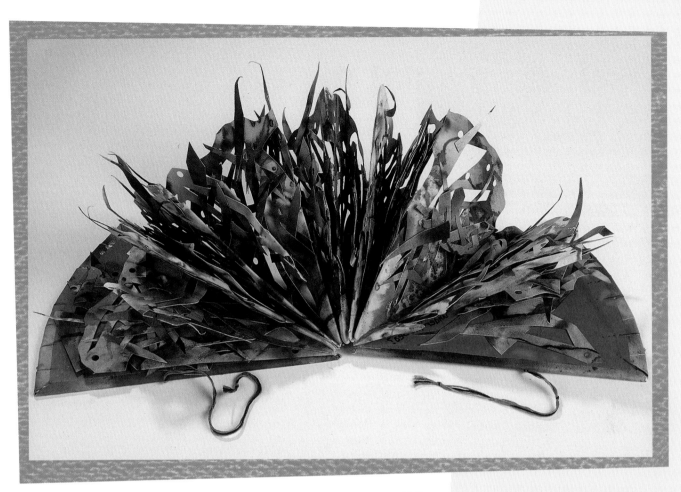

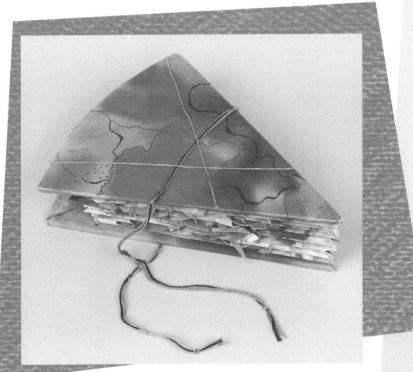

9–1 When the radial book is opened flat, the effect is a half-circle sculptural piece.
Ann Ayers, *Pie R* (open), 1992. Mixed media, 10 x 10 x 9" (25.4 x 25.4 x 22.9 cm).

9–2 Closed radial book. Strings or other fasteners may be used to secure the closed book.
Ann Ayers, *Pie R* (closed), 1992. Mixed media, 10 x 10 x 9" (25.4 x 25.4 x 22.9 cm).

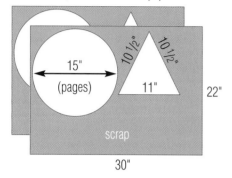

Cut twice, from 2 sheets of paper

15"
(pages)

10 1/2" 10 1/2"

11"

22"

scrap

30"

Procedure

1 Start with two sheets of decorated watercolor paper (see chapter five). On each sheet of paper, use a compass to draw a circle 15" in diameter and a triangle measuring 10 1/2 x 10 1/2 x 11" for the cover paper (see template).

Use scissors to cut out the circles. Save the leftover paper for the cover and to make pop-ups and add-ons.

2 Fold each circle in half. Make sure that the folds are creased sharply.

3 Fold each circle in half again, reducing the circle into fourths. Fold again one last time to reduce the circle into eight equal pie-shaped pieces.

4 Open up the circles. Sharpen the fold lines by re-folding the circles in the opposite direction. Open up the circles again.

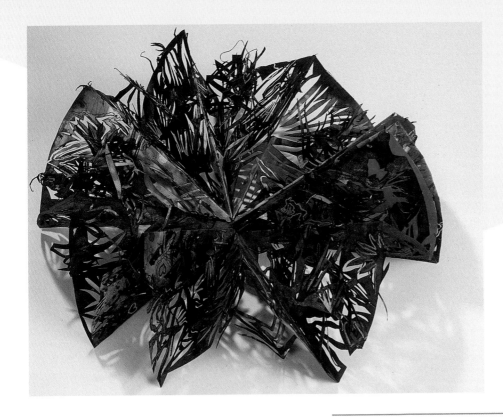

9–3 The artist made many intricate cuts to give this book a more dimensional quality. Cutout pieces were woven back through the cuts to add stability to the lacelike structure.

Alycia Lynn Gold (student), *The Never Ending Circle*, 1992. Dye on watercolor paper, 9 x 9 x 8 ¹/₂" (22.9 x 22.9 x 21.6 cm).

5 Choose one of the folds and cut it from the edge of the paper to the center point. This allows the circle to open up. In the photograph, the circle on the right has already been cut.

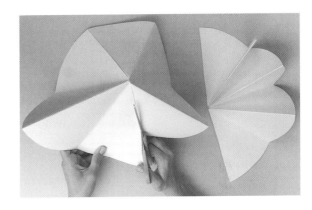

6 With both circles opened up, fanfold the paper by alternating the folds—one up, one down, and so forth.

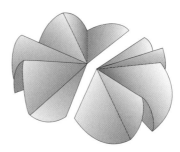

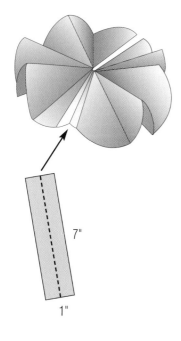

7 From the scrap paper, cut a 7" x 1" rectangular strip. Fold it in half and use this piece to join the two circles together on one side. In order to use this "joiner" piece, you will need to cut it on one end to form a point. If you don't do this before you join the circles, you can glue the joiner piece on and then trim the excess when the glue is dry. Leave the opposite side unattached; these ends will attach to the cover pieces.

At this point, you can cut shapes into the pages to make the book more dimensional. Using a knife or scissors, try following the patterns and designs of the decorated paper. Or, you can create openings that are geometric or organic in nature. The only cutting rule is to avoid too much cutting directly on the folds, which would weaken the book. You might also consider cutting along the curved edge of the paper to make it more interesting.

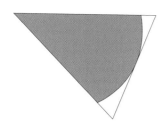

8 For the covers, cut out two triangular pieces of chipboard, each measuring 9 x 9 x 8 1/2". Curve the 8 1/2" side so that the chipboard is rounded to match the folded-up pages of the book. To cut the correct size and shape, use the folded circle pages as a template for tracing.

9 Lay the chipboards on top of the decorated watercolor paper. Remember, these will be your covers, so choose the section of paper you like best. Trace the edges of the cover boards, then add an additional 1 1/2" on all sides. The

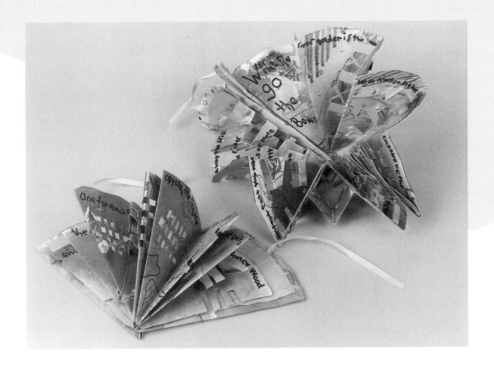

9-4 Elementary school students use books to bridge writing and art, creating a true integration of the arts.

Ashley Watson and Danielle Jones (fourth-grade students), *Untitled Radial Books*, 1995. Mixed media, 6 x 6 x 4 ¹/2" (15.2 x 15.2 x 11.4 cm).

resulting shapes should measure approximately 10 ¹/2 x 10 ¹/2 x 11". Cut them out.

Now lay the chipboards on top of the cutout shapes. Cut the angles as shown and snip lines about an inch apart along the curve. Fold and glue each of the strips onto the cardboard cover. (For specific instructions on gluing cover boards, see chapter six.)

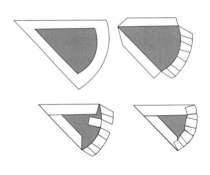

10 Glue the unattached, triangular end pages directly to the covered cardboard. Make sure that the book opens and closes freely.

Between the pages of the book, you can add pop-ups and other pieces cut from decorated paper. Attach beads, wire, or other decorative elements to the cover or pages of the book to add three-dimensional interest. Strings or other fibers may be glued to the cover as decorative or functional ways to secure the book.

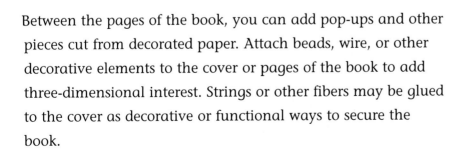

10 Layered Books

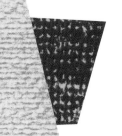

10–1 Although it looks complicated, this basic layered book is essentially made from three layers of paper that nestle one in front of the other. The top two layers are decorated watercolor paper, and the background is a solid-colored paper. The artist used contrasting colors and intricate cuts to invite the viewer in for a closer look at what lies beneath.
Ann Ayers, *Hide and Seek*, 1992. Mixed media, 6 x 10 x 1 ¹/₂" (15.2 x 25.4 x 3.8 cm).

A layered book has multiple layers, each made visible to the viewer by holes or spaces cut into each layered page. These layers give a feeling of depth and complexity to the piece. This type of sculptural book is suited to the needs of both the abstract artist as well as the artist who values realism. The layered book can be very intricate or it can be simple, depending on the theme or the artist's concept.

Two kinds of layered books are featured in this chapter. The first kind is a basic structure consisting of three folded layers that nest one in front of the other. Cutouts in the first two layers reveal the layers beneath (see figure 10–1). The other is an in-the-round, or star, format (figure 10–2). Structurally, it is similar to an accordion book, but it has an additional layer behind the first layer. Windows or openings are cut into the first layer only. When the covers are pulled open and around to meet each other, a star shape is created. The star book is best displayed opened to allow the viewer to enjoy all the dimensions of the book.

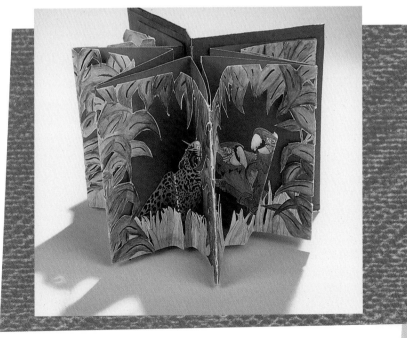

10–2 This in-the-round format is a variation of the layered book. When the covers of the book are pulled around to meet each other, the book takes on a star shape and the layers pop forward. This student artist selected colors and images based on a jungle theme.

Sheetal Sookal (student), *Untitled*, 1996. Mixed media, 8 1/2 x 5 1/2 x 1 1/2" (21.6 x 14 x 3.8 cm).

A Basic Layered Book

Procedure

1 Start with a sheet of decorated watercolor paper (see chapter five for details). Using the first template as a guide, cut three pieces as follows:

• Cut one 12 x 18" piece for the cover. Set this piece aside.

• Cut a 9 x 20" piece for the front layer of the book.

• Cut a 9 x 18" piece for the middle layer of the book.

Using the second template as a guide, take a second sheet of watercolor paper and follow this step:

• Cut one 9 x 17" piece of paper for the back layer.

Note: When planning and constructing the layered book, it is sometimes best to use contrasting papers for the different layers. By using contrasting colors schemes when you decorate both sides of the paper, you can flip the paper over for alternating layers, thus creating visual depth. Because very little is seen of the back layer, it can be created from a sheet of contrasting construction paper or heavyweight paper.

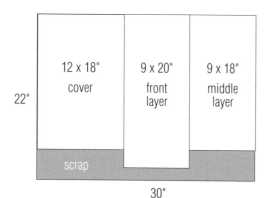

2 Take the front layer piece and mark off four sections. Each section will be 5" wide. Fold on the marked lines.

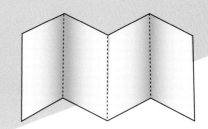

3 Take the middle layer piece and once again mark off four sections. This time the sections will measure 5", 4", 4", then 5". Fold on the marked lines.

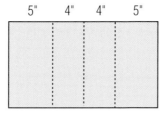

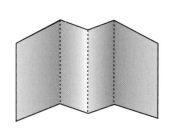

4 Take the back layer piece and measure off four sections as follows: 5 1/2", 3", 3", and 5 1/2". Fold on the marked lines.

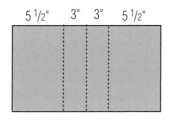

5 Stand the folded layers on end, with the front, middle, and back layers in place. This will be the position of the layers when the book is complete. Visualize where you might cut openings into the first two layers to reveal the layer(s) behind them.

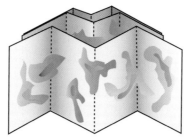

6 Use a craft knife to cut out shapes and openings in the first two layers. The top layer should have the most cutouts, allowing the viewer to see behind it. Use scraps to weave new shapes or to fill voids that look awkward. It is important to check often, to put the layers back together to see how they will look. To add interest to the different layers, use white glue to attach beads, wires, or other types of nontraditional media.

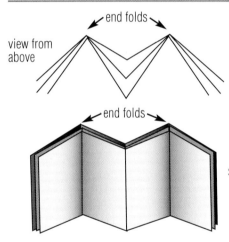

end folds

view from above

end folds

shown without cutouts

7 To assemble the book, place the three layers one in front of the other so that the end folds are on top of each other. Run a line of white glue along the end fold creases. This will hold the book together and still allow the layers to show.

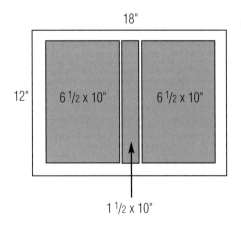

18"

12"

6 1/2 x 10" 6 1/2 x 10"

1 1/2 x 10"

8 Next, make a cover with a spine, as described in chapter six. For the front and back covers, cut two 6 $1/2$ x 10" pieces from the chipboard. For the spine, cut one strip measuring 1 $1/2$ x 10" from the chipboard.

Take your third sheet of decorated watercolor paper and cut a 12 x 18" piece. Place the chipboard on the back side of the watercolor paper, leaving about $1/4$" between the pieces.

Trace around the pieces, to mark where to glue them down. (See chapter six for detailed instructions on gluing and finishing covers.)

9 Fold over the corners and the edges and glue them down. Instead of using two individual end papers, you will use one long sheet of paper that covers both ends and the spine. Cut a piece of paper that measures about 1/2" less on each side than the dimensions of the chipboard and the spine put together (approximately 9 1/2 x 14 1/2"). You can use another piece of decorated paper or paper of a different type and color, depending on the desired effect. When gluing on the end paper, remember to push the paper into the groove that separates the pieces of chipboard so the book will open and close properly.

10 Glue the left and right sides of all three layers to the cover, one in front of the other. In this type of book, the "pages" do not open on the sides like other books—they are all glued down. The middle folded section will come forward, like a pop-up, and will fold up when the book is closed.

Be careful to align the bottoms of the pages with the bottom of the cover so that the book can stand upright when opened without falling over. Open and shut the book a time or two to make sure the layers fit inside the book. If they don't, adjust the placement of the pages before the glue dries. You will need to weight down the book in the open position until the glue dries; otherwise, the wet glue just might glue the pages of the book shut!

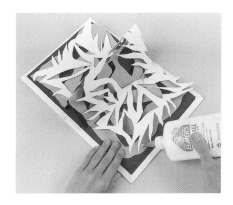

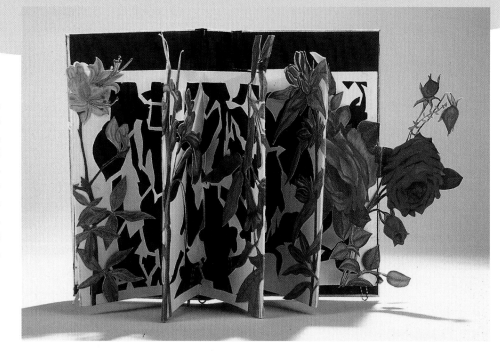

10–3 In this example, an in-the-round format book is displayed only partway open, with the pages jutting forward more like a traditional book. The student artist chose flower imagery as her theme.
Lisa Tekula (student), *Untitled*, 1996. Mixed media, 8 $^1/_2$ x 5 $^1/_2$ x 1 $^1/_2$" (21.6 x 14 x 3.8 cm).

Materials

- two pieces of 22 x 30" heavyweight paper, or three pieces of 18 x 24" tag board
- construction paper or fadeless paper in your choice of colors
- 2- or 3-ply chipboard or mat board that is doubled
- white glue
- tools listed in chapter four

An In-the-Round Layered Book

Construction of an in-the-round or star book is similar to the layered book. Although it might look more complex, it is no harder to make. Essentially there are two long strips of accordion-fold pages, layered on top of one another.

This type of layered book can be viewed in many ways: as a traditional layered book, a hanging sculptural book, or an in-the-round sculptural piece. Once again, this type of book lends itself very well to a theme or concept because it provides a "window" foreground area and a background area for drawings and add-on pieces.

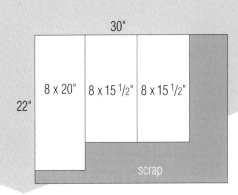

Procedure

1 From a sheet of heavyweight paper or tag board, cut an 8 x 20" piece and two 8 x 15 ¹/₂" pieces.

2 On the longest sides of all three pieces, measure and mark every 5". There will be a ¹/₂" flap left over on each of the 15 ¹/₂" pieces. These flaps are used to join the pieces together.

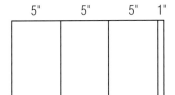

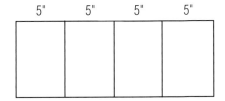

3 Fanfold on the marked lines. Run glue along the ¹/₂" flaps and attach the pieces together. Put the 8 x 20" piece in the center. The length of the joined piece will be 50". This long piece will become the background of the layered book.

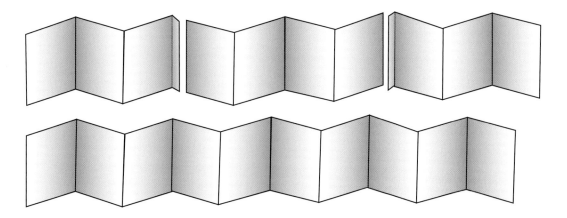

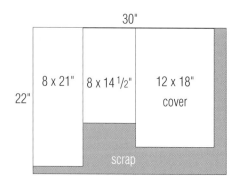

4 From a second sheet of heavyweight paper or tag board, cut an 8 x 21" piece and an 8 x 14 ¹/₂" piece. Cut a 12 x 18" piece for the cover and set it aside.

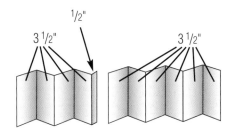

5 On the longest sides of the first two pieces, measure and mark every 3 ¹/₂". There will be a ¹/₂" flap left over on one end of the 14 ¹/₂" piece. This is for joining the two pieces together. Fanfold along each line; press on the folds to make sharp creases.

Use white glue to join the two pieces together. Overlap the ¹/₂" flap on one end of the 21" piece. The joined strip should measure 8 x 35". This piece will be the window or foreground of your layered book.

6 Now is the time to decide the design and the desired outcome of your book. Plan for window shapes and pop-outs you wish to include. When you are ready, use a craft knife to create openings on the foreground strip. One option is to cut windows that cross over one fold into a neighboring section, as shown. This will create five openings.

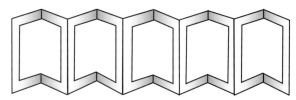

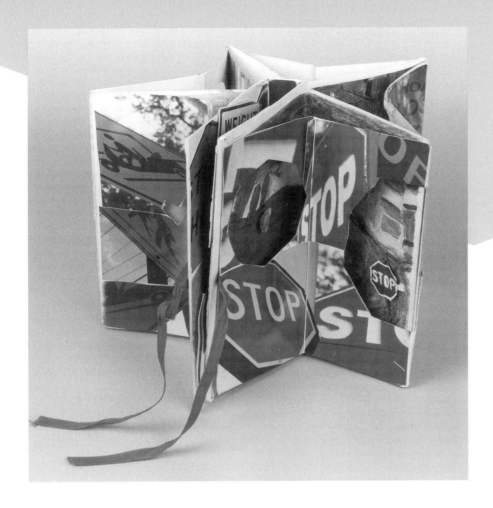

10–4 Ribbons attached to both covers can be used to hold the book open when displayed or to secure it when closed. Other ties such as wire, string, or buckles can also be used. Traffic signs are the theme of this book.

Marcy Connor (student), *Untitled*, 1996. Photo-collage, mixed media, 5 1/2 x 7 1/2" (14 x 19 cm).

7 Place the window strip in front of the background strip to see how they line up. Draw and create your designs directly on both the background and window pages. Keep checking the placement as you go along.

To assemble the pages, run glue along the folds as shown, on the back side of the window strip. Attach the front window pages to the background. Pop-ups can be added to each of the background double sections to add more depth and interest to the pages, as in figure 10–2.

glue

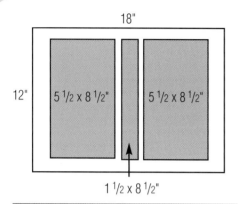

18"

12"

5 ¹/₂ x 8 ¹/₂" 5 ¹/₂ x 8 ¹/₂"

1 ¹/₂ x 8 ¹/₂"

8 For this kind of book, you need a cover with a spine. From chipboard, cut two pieces that measure 5 ¹/₂ x 8 ¹/₂" and one piece that measures 1 ¹/₂ x 8 ¹/₂". For the cover paper, use the 18 x 12" piece you cut and set aside in step 4. Glue the chipboard onto the paper, leaving a ¹/₄" gap between the pieces. (Review chapter six for detailed instructions.)

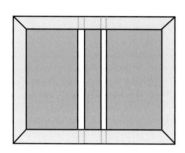

9 Fold or clip the corners, then fold over each side of the cover paper. Secure with glue. Cut an inside cover piece (end paper) measuring 7 ¹/₂ x 12" from construction paper or other type of colored paper. Glue it down to cover the chipboard. Make sure to push the paper into the grooves between the chipboard pieces. Otherwise, the book will not open and close properly.

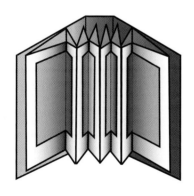

10 When the cover is dry, turn over your long strip of pages, and cover the back of each end page with glue. Press each end to the inside cover, on the left and right sides. Do not glue the spine; this will allow the book to be opened completely. Glue the pages flush at the bottom of the book so that it won't tip over when displayed.

By gluing or tying ribbon or string to each cover, the book can be fully opened and secured. In this position, the two covers are back to back and the pages fan out in a star shape. This displays each page fully, opening up the windows to reveal the layers beneath.

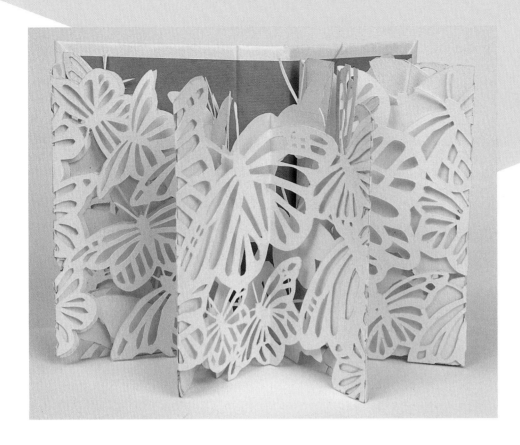

10–5 In this simple yet visually complex piece, the artist has cut intricate butterfly shapes into layered pages made from undecorated watercolor paper. A solid blue paper provides an effective background for the lacy butterflies.

bruce gambill, *Butterflies,* 1996. Watercolor paper, 5 $^1/_2$ x 8 $^1/_4$ x 12" (14 x 20.9 x 30.5 cm).

10–6 This artist chose a theme many city-dwellers can relate to—graffiti. For the background, she cut an eraser into a brick shape and used it as a rubber stamp to make a brick wall pattern. On the front layer are images of graffiti and graffiti artists.

Stacey Jenkins, *Extreme Art,* 1996. Paper, watercolor, marker, 8 $^1/_2$ x 6" (21.6 x 15.2 cm).

11 Pop-up Books

The pop-up book looks like a traditional book on the outside but it has a "surprise" inside. Pop-up structures inside the book may take various forms, some of which look complex, but all are based on simple mechanisms. Creating the pop-ups is basically a matter of cutting and folding.

In this chapter, you will learn how to make two kinds of pop-up books. The 90-degree format only partially opens—it is literally a 90-degree, right-angle presentation (figure 11–1). The 180-degree pop-up can be opened to lay flat on a table, presenting a whole sculpture on a flat base (figure 11–2).

90-Degree Pop-up Book

The 90-degree pop-up book opens only halfway. Although this might seem like a limitation, the book can have either a horizontal or vertical format, making it a very versatile piece of art. When displayed on its side, the book can look like a mini-stage with a backdrop. When displayed upright, in a vertical format, it can reveal intriguing shapes and colors. The artist can develop a theme or simply use shapes and colors to create a mood or feeling. (See figure 11–3.)

Materials

- two pieces of decorated 22 x 30" watercolor paper, 130 lb. weight
- construction paper or fadeless paper in your choice of colors
- 2- or 3-ply chipboard or mat board that is doubled
- 12 x 18" tag board or heavyweight paper for practice
- white glue
- masking tape
- tools listed in chapter four

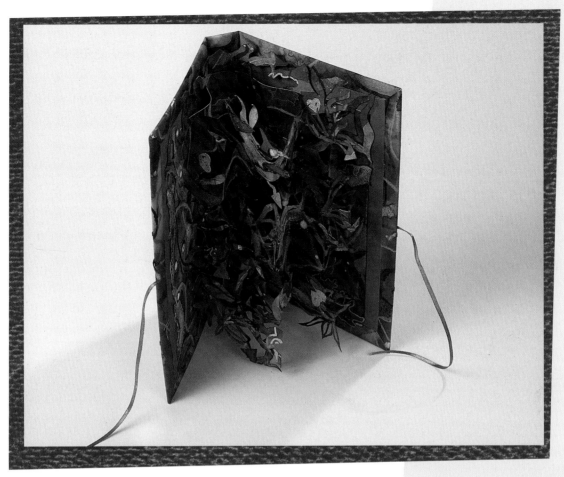

11–1 When opened, this 90-degree pop-up book is a visual feast of color and free-form shapes.
Stacy Barnell (student), *Untitled,* 1994. Mixed media, 8 x 10" (20.3 x 25.4 cm).

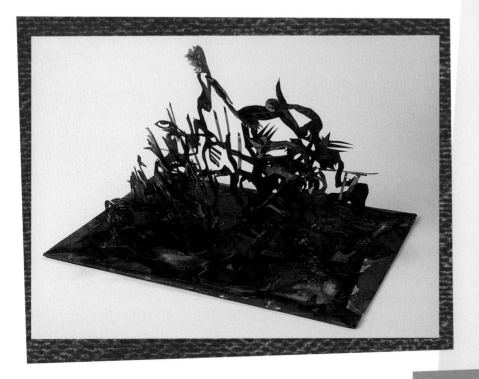

11–2 When this book is opened completely, the pop-up piece rises majestically, creating an impressive sculptural piece. Despite its visual complexity, the steps for making such a structure are fairly simple.
Ann Ayers, *Three Wishes,* 1995. Mixed media, 8 x 13 x 13" (20.3 x 33 x 33 cm).

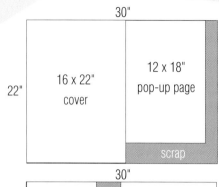

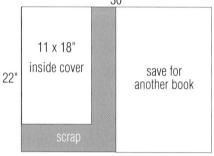

Procedure

1 Start with a sheet of decorated watercolor paper (see chapter five for details). Cut a 16 x 22" piece for the cover and set it aside. Also cut a 12 x 18" piece from the same sheet. This will become the pop-up page inside the book. It is a good idea to also cut a 12 x 18" piece of tag board; you can use this to practice on before cutting and folding the decorated paper.

From the second sheet of decorated paper, cut an 11 x 18" piece. This piece will be glued to the inside front cover and become the backdrop for the pop-up piece.

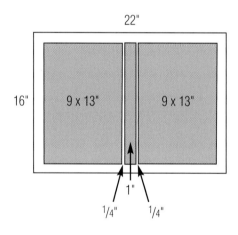

2 To make a cover (with a spine), cut the chipboard into two 9 x 13" pieces and one 1 x 13" piece. Place the decorated cover sheet face-down, and arrange the chipboard pieces on top. Leave a 1/4" space between the chipboard pieces. This is the gluing arrangement—use a pencil to outline where the pieces go.

Use white glue and spread a thin coating on the chipboard. Place the glued chipboard on the watercolor paper. Weight down with books until dry. (See chapter six for detailed instructions.)

3 When the glue has dried, remove the books and cut the corners of the watercolor paper as shown. Fold over the paper on all sides and glue it to the chipboard. Use masking tape, if necessary, to hold the flaps down until dry.

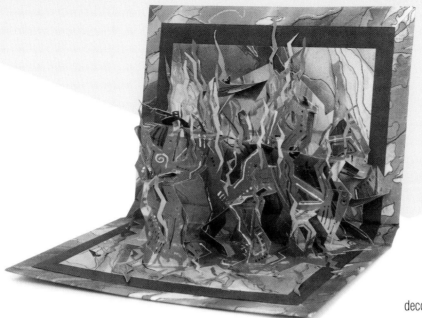

11–3 Cutout pieces attached to the vertical steps of the pop-up piece create an illusion of complexity.

bruce gambill, *Nocturnal Tetude*, 1996. Watercolor paper and dye, 13 x 9 ¼ x 13" (33 x 23.5 x 33 cm).

covered chipboard
approx. 13 x 19 ½"

solid colored paper
12 x 19"

decorated watercolor paper
11 x 18"

4 Glue a piece of solid color paper, approximately 12 x 19", inside the cover to hide the chipboard. Then take the 11 x 18" piece of decorated watercolor paper and glue it over the solid paper. Force the paper into the grooves of the cover. Fold where appropriate to make the book close.

5 The next steps describe the cutting and folding pattern that forms the pop-up part of the book. Use the 12 x 18" tag board to practice with before you use your best paper. It may take a few tries to get the effect you want.

You will notice that the folded sections look like stairs. This type of cutting is called "generations" in pop-up terminology. Every pop-up is based on an existing fold and generates its own new fold. Each new fold can be cut to create another pop-up, which in turn generates a new fold, and so on for several generations.

Start by folding the paper in half. About 1" in from the edge, mark and cut 4" parallel lines that start from the folded edge.

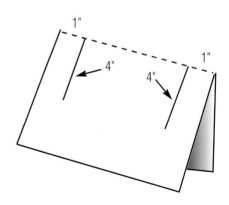

1"

4"

4"

1"

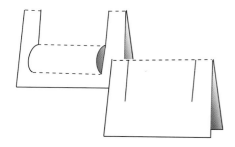

6 Fold down the section in the middle of the cut lines. Press hard to make a sharp crease. Fold the section back the other way, then return it to the original position.

7 Open the paper slightly and push the folded piece down into the inside of the paper. Press hard to make sharp creases again. When you are finished, open to see the first pop-up step.

8 Re-fold the paper with the pop-up step inside. Mark and cut a 2" set of parallel lines, about 1" in from the cut edge. You will just cut through the top folded section of the pop-up.

9 Once again, fold the cut section forward and backward, then return it to its original position.

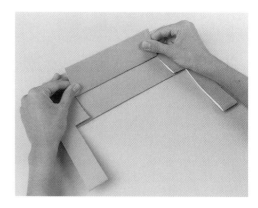

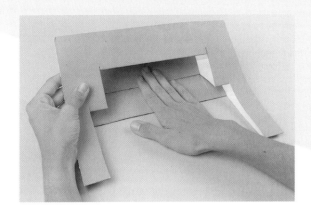

10 Open the paper slightly and push the new folded section down to the other side. Press hard to make a sharp crease—try pressing along the crease with scissors or a blunt instrument. Open to see the pop-up.

11 Re-fold the piece with the pop-up section inside, and repeat steps 8 and 9 on the other side of the first step. This will create a third step. Once you get the hang of this procedure, you may want to cut more sections to create a series of steps within steps. When you are comfortable with the pop-up cutting and folding process, switch to your decorated watercolor paper and create a pop-up piece from your "real" paper.

12 After you have created your pop-up structure, you can cut openings into the paper. This will increase the visual complexity of the piece. Make your cuts before you glue the pop-up to the cover.

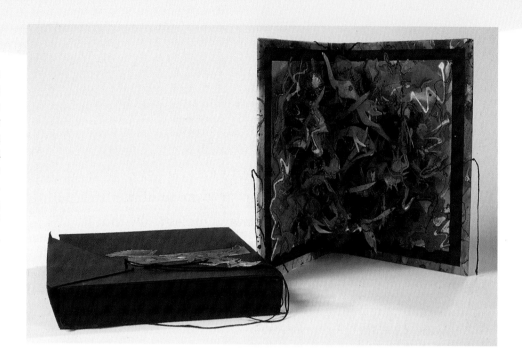

11–4 This 90-degree pop-up book was designed to be viewed vertically so that the shapes and colors are highly visible. The artist created a custom slipcase to protect the book when it is not on display (see chapter fifteen).
Ann Ayers, *Purgatory*, 1992. Dye on watercolor paper, 9 x 13" (22.9 x 33 cm).

13 When you are ready to glue, it is important that you prop the book cover open only halfway (at a 90-degree angle). Glue only the uppermost and lowermost edges of the pop-up section to the cover of the book. Before the glue dries, check to make sure the pop-up does not protrude from the closed cover.

From the scrap watercolor paper, you can cut additional shapes and forms. Glue them to the steps of the pop-up piece of paper. Make sure to glue the shapes on the same planes of the steps so that the book can close properly—in other words, glue the shapes on either the vertical steps or the horizontal steps. If you glue shapes on both vertical and horizontal steps, then the shapes can get caught up in each other, which can cause problems when you close the book. Scraps can also be glued behind the steps to fill any voids created when you cut and folded the steps.

180-Degree Pop-up Book

Unlike the 90-degree pop-up book, the 180-degree book opens completely flat, forcing a large pop-up structure to stand when it is opened. The pop-up structure opens so majestically that it is perplexing to figure out exactly how the mechanism works.

However, construction of the pop-up follows the same basic directions for the 90-degree pop-up. The difference is that instead of one, there are two pop-up structures connected together.

Procedure

1 Start with a sheet of decorated watercolor paper (see chapter five for details). Cut a 16 x 20" piece for the cover and set it aside. Also cut a 9 $1/2$ x 18" piece from the same sheet. This will become the pop-up page inside the book. It is a good idea to also cut a 9 $1/2$ x 18" piece of tag board; you can use this piece to practice on before cutting and folding the decorated paper.

From the second sheet of decorated paper, cut a 12 x 16" piece. This piece will be used for the inside cover of the book.

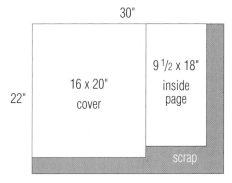

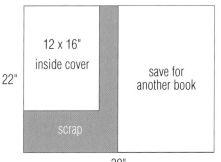

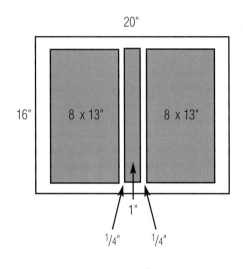

20"

16"

8 x 13" 8 x 13"

1"

¹/₄" ¹/₄"

2 To make a cover (with a spine), cut the chipboard into two 8 x 13" pieces, and one 1 x 13" piece. Place the decorated cover sheet face-down, and arrange the chipboard pieces on top. Leave a ¹/₄" space between the chipboard pieces. This is the gluing arrangement—use a pencil to outline where the pieces go.

Spread a thin coating of white glue on the chipboard. Place the glued chipboard on the watercolor paper. Weight down with books until dry. (See chapter six for detailed instructions.)

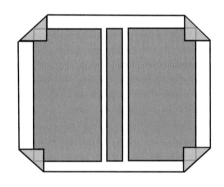
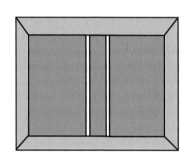

3 When the glue has dried, remove the books and fold over the corners of the watercolor paper. Fold and glue down the flaps on all sides. Press hard around the chipboard so that the corners are sharp.

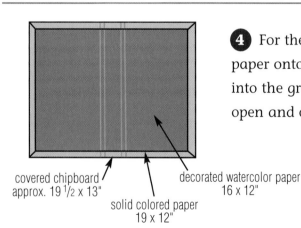

4 For the inside cover, glue the 12 x 16" piece of decorated paper onto the chipboard. Make sure that the paper is pressed into the grooves between the chipboard, or the book will not open and close properly.

covered chipboard
approx. 19 ¹/₂ x 13"

decorated watercolor paper
16 x 12"

solid colored paper
19 x 12"

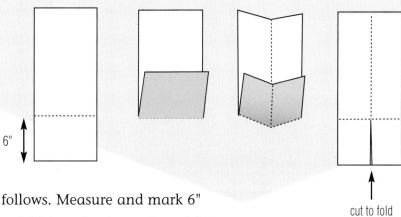

6"

cut to fold

5 Cut and fold the paper as follows. Measure and mark 6" from the bottom of the paper and fold on this line. Then, fold the paper in half lengthwise. Open the paper and cut to the horizontal fold, as shown.

6 Fold the two lower sections up. Each half will be cut and folded to generate pop-ups. Along the folded line, make two pairs of cuts that extend about halfway up the folded section. At this point, rather than measure, you might prefer to experiment and see what works for you. For this type of book, you will be creating two pop-up sections from the same sheet. You can make the pop-up sections symmetrical, as shown, or completely different.

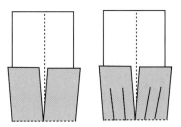

7 Fold each cut section up, then down, making a sharp crease. Push this piece through to the inside. This will be the first pop-up step.

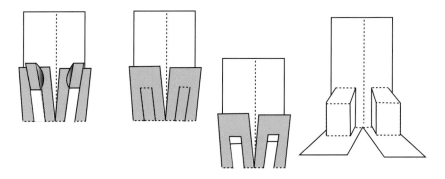

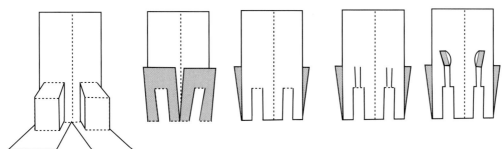

8 Re-fold the piece and flip the lower section to the back. Cut two more pairs of lines on both sides, but this time only cut through the top layer. Fold the cut pieces up, then down again, finally pushing the pieces through to the inside to create another pop-up step.

9 Continue making more pop-up generations on the top section of each side. When you feel comfortable with the process of pop-up folding, you can switch to your decorated watercolor paper and repeat the process. When your pop-ups are finished, you can alter the edges of the pop-ups or cut negative spaces with scissors or a craft knife.

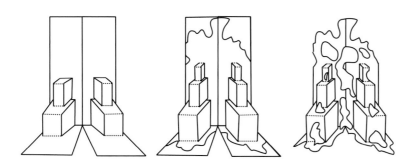

10 When the pop-up piece is finished, position it near the top quarter of the cover with half of the pop-up on the left side, the other half on the right. While it may seem impossible, this

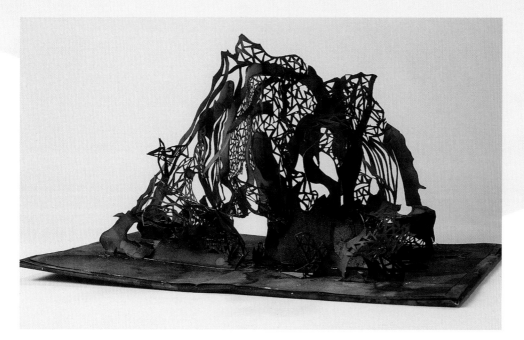

11–5 Although this pop-up piece looks larger than the cover, it tucks completely inside the book when closed. Meredith Filcman (student), *Lace Forest*, 1995. Mixed media, 8 x 13 x 13" (20.3 x 33 x 33 cm).

positioning allows the pop-up section to fold down into a closed cover. Before you glue it down, you may want to gently tape the pop-up into place and practice opening and closing the cover.

Additional pieces may be glued onto the horizontal and vertical planes to add interest and a look of complexity.

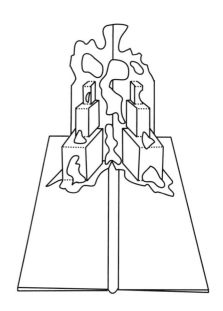

Both types of pop-up books can be set to a theme. Think about families, birds, fish, cities, windows, or rainforests and consider the possibilities that the pop-up book might lend to these themes. Photographs or drawings can be added to the planes of the steps.

You can even position and glue two 90-degree pop-up pieces back to back to create another type of 180-degree pop-up book. The versatility of the pop-up book is endless. Both realist and abstract artists would be equally delighted with the possibilities that this type of book suggests.

12 Pop-out Books

Materials

- one decorated sheet of 22 x 30" watercolor paper, 130 lb. weight
- 4 1/2 x 14" construction paper or fadeless paper in your choice of color (optional)
- 2- or 3-ply chipboard or mat board that is doubled
- white glue
- tools listed in chapter four

At first glance, this looks like an ordinary book—rectangular in shape with an intriguing cover. But open it up and a whole conglomeration of shapes and colors literally pops out to meet you. This is the pop-out book! A pop-out book differs from a pop-up book in that the interior of the book pops forward rather than upwards.

Based on origami folds, the pop-out book is made up of a single piece of paper, folded so that it pops out of the cover when opened. Added-on pieces and cutouts make the book look more interesting and complex. While seemingly complicated, the book is simply a piece of paper that is folded according to a series of steps.

Origami, the Japanese art of folding paper, requires a series of mountain folds (folds that rise up) and valley folds (folds that form a **V** and push down). If you are familiar with origami folds, you will recognize many of the different folds and tucks that are used to create the pop-out piece for this book. An exploration of other origami-type folds might inspire a whole new range of ideas for an exciting book format (figures 12–1 and 12–2).

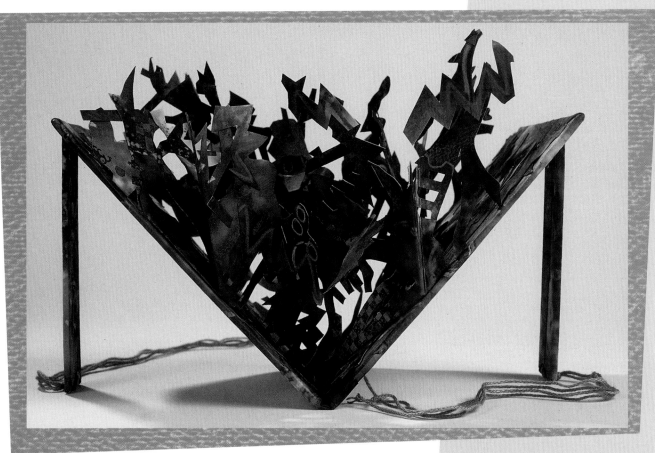

12–1 This pop-out book, displayed open with the use of cardboard props, raises questions for the viewer. How can this book fold up? Do all of those pieces really fit inside? (They do!)

Ann Ayers, *Surprise Reaction*, 1996. Mixed media, 5 $^1/_2$ x 7 $^1/_2$ x 11" (14 x 19 x 27.9 cm).

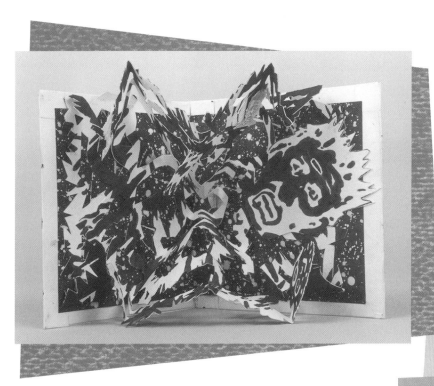

12–2 An artist has several options in displaying the pop-out book. The book can be displayed vertically, horizontally, or propped open— each creating a unique sculptural piece. This black-and-white pop-out book is displayed with the covers stretched out horizontally.

Raymond Sepulveda (student), *Untitled*, 1996. Mixed media, 5 $^1/_2$ x 7 $^1/_2$ x 11" (14 x 19 x 27.9 cm).

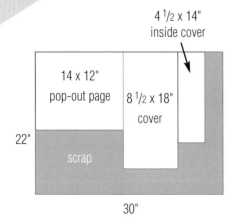

4 1/2 x 14"
inside cover

14 x 12"
pop-out page

8 1/2 x 18"
cover

22"

scrap

30"

Procedure

1 Start with a sheet of decorated watercolor paper (see chapter five for details on decorating paper). Cut a piece of the watercolor paper to measure 12 x 14". This will be your pop-out page. Also cut an 8 1/2 x 18" piece for the cover and a 4 1/2 x 14" piece for the inside cover. Set these aside.

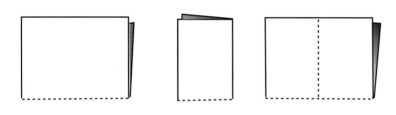

2 Take the 12 x 14" piece and fold it in half along the 14" side. Fold it in half again in the other direction, then open it back up.

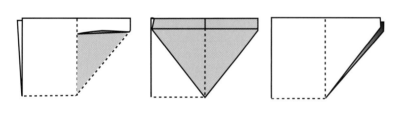

3 Fold the bottom right corner up so that it meets the center fold. Unfold and push the bottom right side up until it lies across the top. Then fold the left triangular section back and tuck the folded section inside.

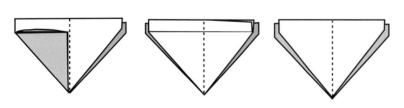

4 Repeat the folds in step 3 on the other side. This time, fold the bottom left corner up to meet the center fold. Unfold and push the bottom left side up until it lies across the top. Fold the triangular section back, tucking the folded section inside.

5 For the next set of folds, start on the right side. Fold the top triangular layer back until it overlaps the center fold by about $1/2$ inch. Reverse the fold and tuck it inside. Do the same for the left side, again tucking the folded section inside.

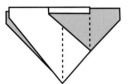 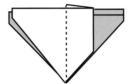 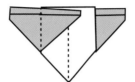 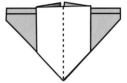

6 Turn the paper over and repeat the folds in step 5 until the paper looks like the diagram.

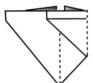 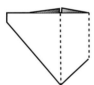

7 Open up the folded paper. This is your basic pop-out page. Now, use a craft knife or scissors to cut openings in the paper. You can cut the edges so that they are no longer a part of a rectangular shape, but be careful not to weaken the structure by cutting too much out of the folded edges.

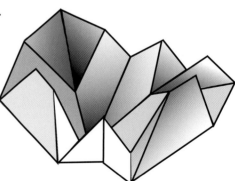

8 To prepare a cover, cut two pieces of chipboard that measure 5 ¹/₂ x 7". Place your 8 ¹/₂ x 18" cover sheet face-down and position the chipboard on top. Allow a space of about 1 inch between the two boards. This space will allow the book to open and close easily.

Trace around the pieces to mark where to glue them down. Once the chipboard is glued in place, fold over the corners of the cover paper and glue them to the board. Weight down the covers with books until dry. (See chapter six for detailed instructions.)

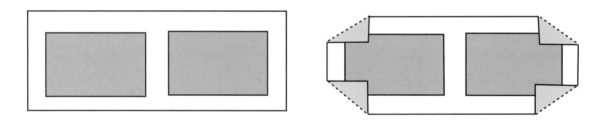

9 When the glue has dried, fold over the watercolor paper on all sides and glue it to the chipboard. Take the 4 ¹/₂ x 14" piece of decorated paper you cut earlier (or a contrasting solid color paper) and glue it to the inside cover sheet, covering up the chipboard.

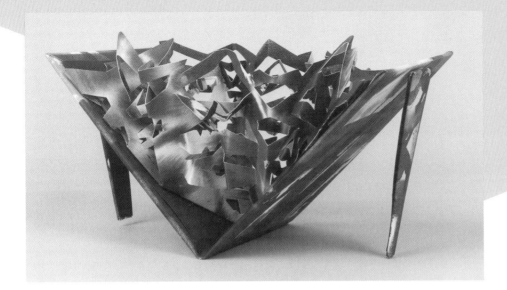

10 Glue the folded structure into the cover so that it does not open up any further than a 90-degree angle. To do this, open the cover into an **L** shape—you may have to prop it up at this angle. Position the pop-out piece so that it fits the cover. Apply glue only where needed to keep the pop-out piece in place, usually near the edges of the book. Add shapes or pop-up pieces to the inside planes and between the folds to add more intrigue to the piece.

The book may be displayed vertically, horizontally, or propped open—with each view creating a totally different sculptural piece. If you want to display the book in a fixed, open **V** shape (figures 12–1 and 12–3), one option is to cover some 1 x 6" pieces of chipboard with scrap watercolor paper and attach them to the cover with paper hinges.

13 Tunnel Books

Materials

- two pieces of 22 x 30" heavyweight paper (tag board is ideal)
- paints or other wet media
- colored pencils
- inks, watercolors, markers
- construction paper or fadeless colored paper
- white glue, rubber cement, or glue stick

optional

- tissue paper
- photocopies of background designs
- magazine pictures or photographs
- tools listed in chapter four

Imagine looking into a book with a series of windows and seeing a three-dimensional picture or shapes and colors on different levels that create a unified image. This is a tunnel book—a book made of individual pages with a central opening, or window, held together by accordion (fanfolded) sides.

The tunnel book originated as a children's book—a variation on the classic pop-up book—to add interest to children's reading. A children's tunnel book is marketed as a "magic window" with a theme—for example, outer space or life under the sea. The child reads text on the first two pages, then looks through a window into a three-dimensional scene.

With a tunnel book, the artist has an ideal format for using a progression of images to create depth. You can work within the traditional format of a window book to create a scene. Or, you can create a more dramatic sculptural effect by emphasizing light and shadow. You can literally lift the book to a new level by supporting it on sticks, dowels, bamboo skewers, wire, or other supports.

This type of book lends itself quite nicely to a theme. Ideas for a thematic concept can be found in nature, stories, photographic images, historical events, mythology, or personal experiences. However, a nonobjective or abstract tunnel book can be based on color theory, patterns, shapes, and textural variations. (See figures 13–1 and 13–2.)

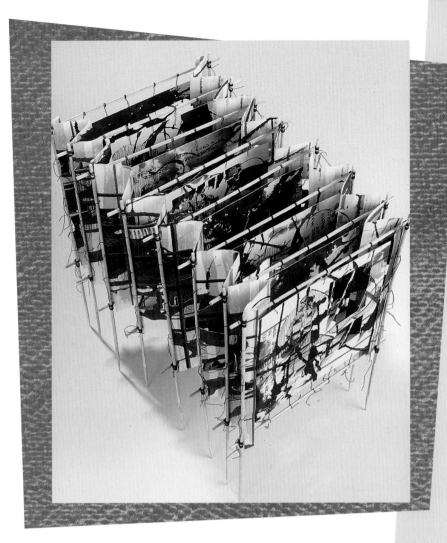

13-1 This tunnel book, viewed from above, is elevated by bamboo skewers that are wired to the outside folds of the tunnel book. Other materials such as wire, sticks, dowels, or rigid plastic tubing could be used to raise the book and create a more sculptural piece.

bruce gambill, *Travois Labyrinths,* 1991. Mixed media, 8 x 12 x 14" (20.3 x 30.5 x 35.6 cm).

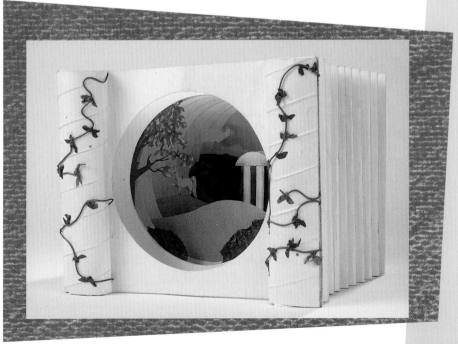

13-2 The artist chose a fantasy theme for this detailed tunnel book. The viewer peers through the openings to see a delightful three-dimensional scene.

Alex X. Cruz (student), *Greek Pangea,* 1990. Mixed media, 7 1/2 x 9 x 14" (19 x 22.9 x 35.6 cm).

Procedure

1 The first step in creating a tunnel book is to decide on a theme. Your theme will influence the type of paper you use, choice of color, and the shape of the tunnel openings. Materials can vary, but it is important to use heavyweight paper for structural strength.

Cut the heavyweight paper or tag board into eight 7 1/2 x 9" pieces, as shown in the template. These will be the actual pages of the book. It helps to make thumbnail sketches of each of the pages, to think through the content of each one and how they will relate to one another. You can paint or draw on the pages, or cover the pages with collage materials such magazine pictures, tissue paper, machine-made copies, or photographs (figures 13–3 and 13–4).

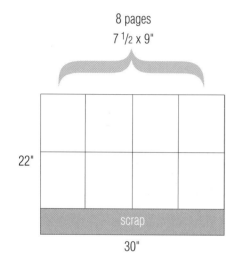

8 pages
7 1/2 x 9"

22"

scrap

30"

2 Cut openings in the 7 1/2 x 9" pieces with a craft knife or scissors. The shape and size of the opening can vary. The openings may get smaller or larger as they get further away from the viewer. Preserve at least a 1 1/2" border on the left and right sides of each page. The last page of the tunnel book can be left uncut to provide a background for the pages in front. Feel free to add cutout shapes, objects, words, or other items that relate to your theme.

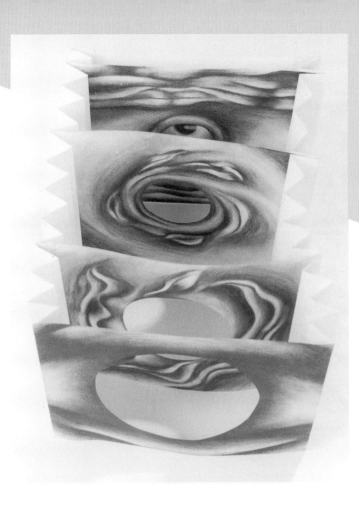

13–3 In the view from above, notice how the openings get progressively smaller with each page of this tunnel book. By making thumbnail sketches ahead of time, you can envision how your completed book will look. With planning, a mere four pages can have a striking effect.

13–4 As you look directly through the openings of the book, notice how the artist used charcoal shading to strengthen the feeling of depth. Openings that go from larger to smaller also promote the sense of peering down a tunnel.

William King, *Deep Into Spaces*, 1995. Pencil on tag board, 7 1/2 x 9 x 14" (19 x 22.9 x 35.6 cm).

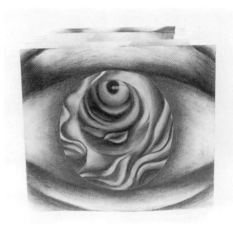

3 Cut two pieces of tag board that measure 7 1/2 x 18". These will be the sides of the book. Also cut twelve 1 x 7 1/2" strips and set these aside. They will be used later as hinges to attach the inner six pages to the sides.

twelve 7 1/2 x 1" pieces for hinges

22"

7 1/2 x 18" accordion side

7 1/2 x 18" accordion side

scrap

30"

4 Measure and mark 1" wide strips on the 7 1/2 x 18" pieces. Use a pencil to lightly draw the inch lines on the tag board. You may want to draw these lines on both sides of the paper.

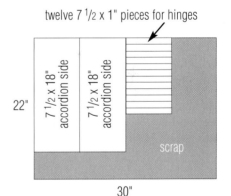

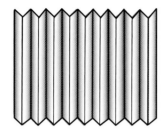

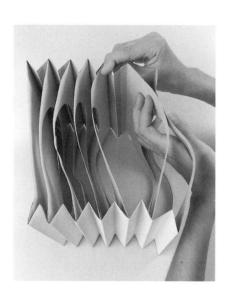

5 Use the blunt side of the knife (or the scissors blade) and a ruler to score the lines. For best results, score every other line on one side of the paper, then turn it over and score the alternating lines. Fanfold both 7 ¹/₂ x 18" pieces of paper.

6 Take the twelve 1 x 7 ¹/₂" strips that you cut out in step 3. Score and fold down them lengthwise down the middle. Set aside the first page and the last page of your tunnel book. On the remaining pages, glue two folded strips to the back of each page, one on the left, one on the right. Position each strip so that the fold lines up with the edge of the paper.

7 To assemble the book, attach the pages to the accordion sides. Start at the back by gluing the back page to the ends of the accordion sides. Attach the second-to-last page by putting glue on the folded side strips and tucking them into the accordion fold in front of the last page. Continue attaching each page until you reach the front of the book.

Skip the fold nearest the front and attach the front page directly to the front of the accordion sides. There will be an "empty" fold between the first and second pages. This helps create a feeling of depth.

For finishing touches, use bamboo skewers, dowels, or sticks to raise the tunnel book and create a more sculptural piece, or make a slipcase to hold the book (see chapter fifteen).

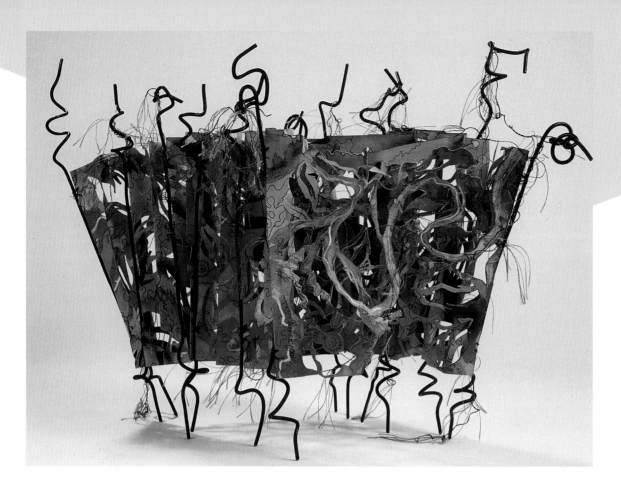

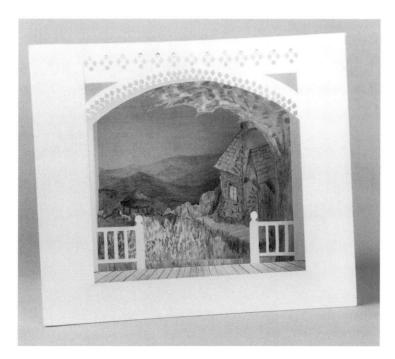

13–5 This tunnel book has been elevated with twisted wires, forming a unique and complex sculpture.

Stacy Barnell (student), *Wired,* 1995. Mixed media, 7 1/2 x 9 x 14" (19 x 22.9 x 35.6 cm).

13–6 Both realistic and abstract themes work well in the tunnel book format. In this combination of three-dimensional layers and drawings, an illustration is brought to life. Notice the detailed, intricate patterns cut into the upper part of the front window.

Anita Beaumont, *Untitled,* 1993. Mixed media, 7 1/2 x 9 x 14" (19 x 22.9 x 35.6 cm).

14 Two Variations

The different bits and pieces of sculptural books, and the techniques used to create them, can be combined in different ways to create new types of sculptural books. Think of a tunnel book that has fanfolded pages like an accordion book. Think of an accordion book with pop-up pages. How about a layered pop-up book? The possibilities are endless.

This chapter covers two variations of sculptural books. Like the accordion book, they have hard covers attached to an expanse of unfolding papers. When pulled and stretched, these pages can be arranged in exciting positions, presenting unusual and diverse sculptural pieces.

Begin these books like any other, by decorating or choosing the paper that will become the pages of the book. For these two book formats, contrasting colors—particularly complementary colors—are especially effective. Your choice of paper can evoke a particular mood or impact the way the viewer perceives the work.

Triangular Book

This particular book is perhaps one of the easiest sculptural books to make, yet it has an intriguing and unique presentation. The book is essentially made by repeatedly folding one long strip of decorated paper.

Materials
- one decorated sheet of 22 x 30" watercolor paper, 130 lb. weight
- 2- or 3-ply chipboard or mat board that is doubled
- white glue
- tools listed in chapter four

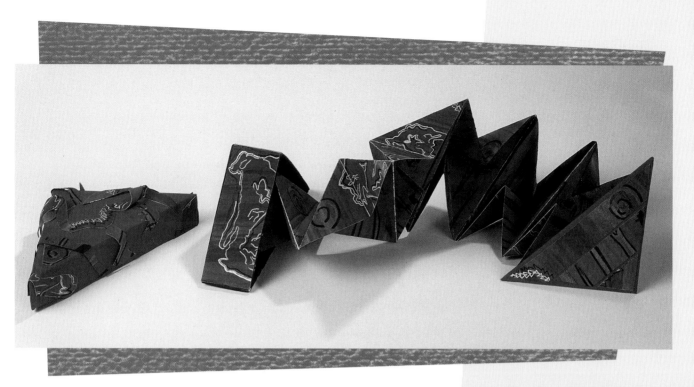

14–1 The triangular book above is a variation of an accordion book—both are made from a long strip of paper with a series of folds. The three-dimensional effect is enhanced by watercolor paper dyed with complementary colors on opposite sides.

Emily L. Busch (student), *Twilight and Sunrise,* 1996. Watercolor, acrylic, permanent marker, paint marker, 5 x 5 x 36" (12.7 x 12.7 x 91.4 cm).

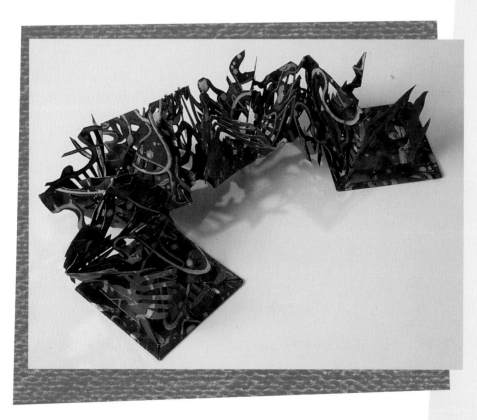

14–2 This fold-out book combines aspects of the pop-out book and the accordion book. Cutout shapes and added pop-up pieces give the book an intricate, dynamic look.

Ann Ayers, *Pocket Book,* 1994. Ink on watercolor paper, 4 x 4 x 36" (10.2 x 10.2 x 91.4 cm).

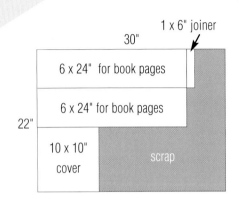

Procedure

1 Start with a sheet of decorated watercolor paper (see chapter five for details on decorating paper). Cut two pieces that measure 6 x 24". These will become the pages of the book. Cut a 10 x 10" piece for the cover and set it aside. Also cut one strip that measures 1 x 6".

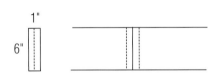

2 Draw a line vertically down the middle of the 1 x 6" strip, then fold along that line. Unfold the strip, lay it flat, and apply glue. Join the two 6 x 24" papers by placing them on the strip on either side of the fold.

3 Bend the top left corner of the strip down until the left edge meets the bottom. Press along the diagonal fold to make a triangular shape.

4 Continue folding diagonally, edge to edge, back and forth, until the entire strip is folded.

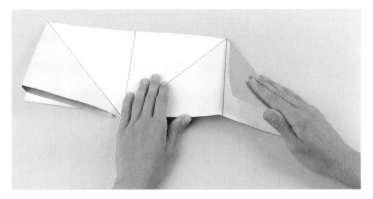

5 After folding all the sections, open up the strip. There will be sixteen triangular sections in all, which can be treated as "pages." Make sure that the creases are sharp.

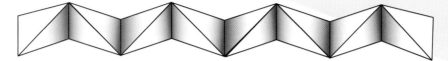

6 For covers, cut a square piece of chipboard that measures 6 ¹/₂ x 6 ¹/₂". Draw a diagonal line from corner to corner, and cut the piece in half to form two triangular pieces.

7 Take the 10 x 10" piece of decorated paper from step 1 and cut it in half diagonally. Place the decorated sides face-down. Glue the chipboard pieces to the back side of the cover papers with even margins on all sides. Weight them down with heavy objects until dry. (See chapter six for detailed instructions.)

For each cover, clip the corners and fold the decorated paper over onto the cardboard. Glue down the flaps.

8 Apply glue to the triangular shape at one end of the long strip of folded paper. Press it directly onto one of the covers. Do the same at the other end of the strip. Weight down with books until the glue is dry.

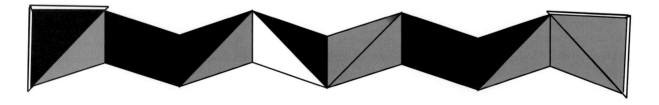

Materials

- two decorated sheets of 22 x 30" watercolor paper, 90 lb. weight
- 2- or 3-ply chipboard or mat board that is doubled
- white glue
- tools listed in chapter four

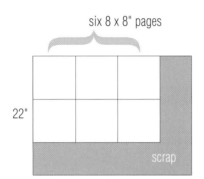

six 8 x 8" pages

22"

scrap

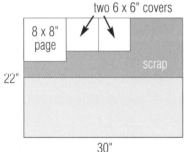

two 6 x 6" covers

8 x 8" page

scrap

22"

30"

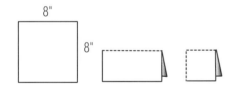

8"

8"

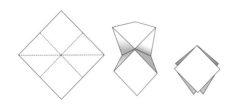

The Fold-out Book

Our second accordion book variation is based on folded triangles and squares. The fold-out book can be made very large or very small—either size is effective. Like the triangular book, construction is fairly simple and display possibilities are numerous. For this type of book, use 90 lb. watercolor paper or tag board instead of 130 lb. watercolor paper, which may be too heavy to fold properly.

Procedure

1 Start with two sheets of decorated watercolor paper (see chapter five for details on decorating paper). Cut two 6 x 6" pieces for the cover, and set them aside. Cut seven squares that measure 8 x 8". These will become the pages of the book.

2 Fold each of the seven 8 x 8" squares as follows. Fold the paper in half, then in half again. Open and reverse the folds to make creases flexible.

3 Lay the square out flat, then fold it in half diagonally from corner to corner. As before, open and reverse this fold to make it more pliant.

Fold the triangular sections inward toward each other. Tuck them in until they are covered by the squares when the paper is flattened. Fold all seven pieces of paper in the same way.

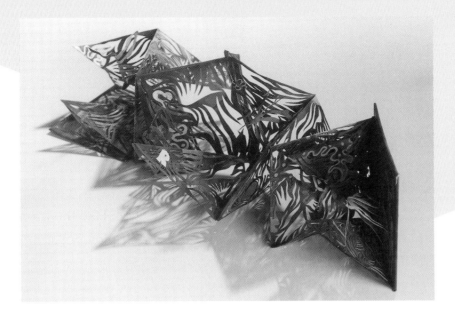

14–3 Pop-up pieces or cutout sections may be added to further decorate the book. This type of book is particularly interesting when displayed at different levels, like stairs, so the book sections can "spill" from level to level.

Alycia Lynn Gold (student), *Love*, 1994. Ink on watercolor paper, 6 x 6 x 36" (15.2 x 15.2 x 91.4 cm).

4 To join the folded pages, you will overlap the square sections and glue them together. The first page will point up, the next will point down, and so forth. It is usually best, especially with heavy paper, to lay the pages out flat and systematically overlap them, as shown.

 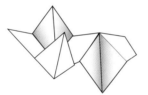 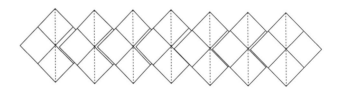

5 For covers, cut two pieces of chipboard that measure 4 1/2 x 4 1/2". Cover each with 6 x 6" pieces of decorated paper. (See chapter six for detailed instructions.) Glue the end squares of the folded book directly to the covers.

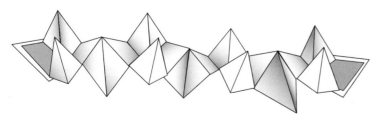

15 Finishing Touches

Once you have finished the basic structure of your sculptural book, you might want to add a little something extra. Thoughtful and unusual elements can make your finished piece more interesting and enhance its sculptural qualities.

If you want a sparkle effect, you could add glitter to your book. Glitter is best added last, as it is likely to rub off if applied too early, and the glue that attaches the glitter might interfere with cutting and folding steps.

Strings, threads, and other types of fibers add another dimension to a book. Because you don't usually see threads in a book, the contrast in materials is unexpected. As a practical finishing touch, you might attach string or ribbon to the cover for fastening the book shut.

Any number of added elements might push your book further in the direction of sculpture. As you've seen in previous chapters, sculptural books can be mounted on stilts—sticks, twigs, bamboo skewers, dowels, or metal rods. For example, you can drape an accordion book over a painted tree branch and secure it with wires or thread. By lifting your book away from a flat viewing surface, you create a more dramatic, open presentation.

15–1 By attaching bent Plexiglas rods to the vertical edges of the pages of this accordion book, the artist has created a unique in-the-round sculpture.
Allison Gillam, *Organized Confusion*, 1994. Mixed media, 12 x 8 x 4" (30.5 x 20.3 x 10.2 cm).

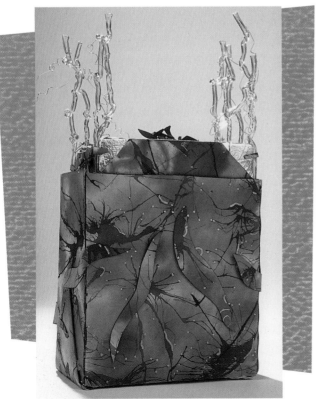

15–2 The slipcase for the accordion book above (now closed) was planned as the book was constructed. Sections of the same decorated watercolor paper were used throughout. The basic pattern for this simple slipcase is described in this chapter.

Allison Gillam, *Organized Confusion with Slip Case*, 1994. Watercolor paper and dye, 12 x 8 x 4" (30.5 x 20.3 x 10.2 cm).

Materials

- one sheet of 22 x 28" (or larger) medium weight board, such as posterboard
- white glue or tacky glue
- tools listed in chapter four

15–3 A slipcase constructed from posterboard is the most common and easiest to construct. This one is designed to coordinate with the artist's book and to protect it when the book is not on display.

June Reichenbach, *Alphabet Fish Slipcase*, 1990. Posterboard, 8 1/2 x 13" (21.6 x 33 cm).

Slipcases

A slipcase is any cover used to protect a sculptural book. You can make a slipcase from any number of materials, and customize it to fit the shape, style, and theme of your book. It can be complex and elaborately designed, or a simple posterboard covering that complements the colors of your book.

Some slipcases are primarily meant to protect the book when it is not open for display. Others are intended to be part of the work and are shown alongside the book on exhibit. You've seen a number of examples in this book. Either way, creating a case for your sculptural book can be the final act that completes your work of art. Three different templates for making a slipcase are provided in this chapter.

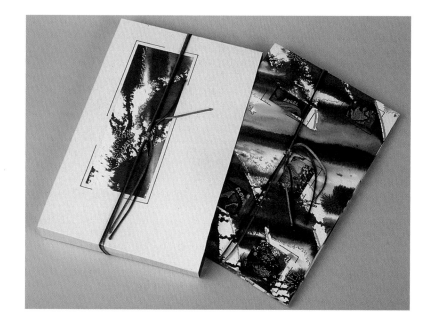

Basic Procedure

1 Think about different materials and colors you can use for your slipcase. Do you want the case to match the book, or do you want a contrasting effect? The simplest slipcase is one constructed from posterboard. Template 1 creates a slipcase that is open on one end.

2 Obviously, because all books are not the same size, you will need to measure and plan ahead. Template 1 lays out the basic formula for making a slipcase. Your case might look quite different once you have adjusted it to fit your book. You may want to start by making a copy of the template, then writing in measurements that are specific to your book. You will need to add 1/4" to 1/2" to the dimensions of the book as shown in the template. Add the dimensions across the width and the length to determine if the book can be cut from a standard piece of posterboard (22 x 28"). If not, use a larger piece of board.

3 With a pencil, draw your customized pattern onto the posterboard. Be sure to mark which are cut lines and which are fold lines. Use a craft knife and metal ruler to cut the outside edges of the pattern. Then cut on the lines that will separate flap A-1 and B-1.

4 Score and fold along the fold lines of the slipcase. Check the folded case against the book to make sure it fits. Then, glue the flaps with tacky glue and hold firmly until it bonds. You could use a clothespin or other kind of clamp for this purpose. When dry, the slipcase can be enhanced or embellished to coordinate with the book inside.

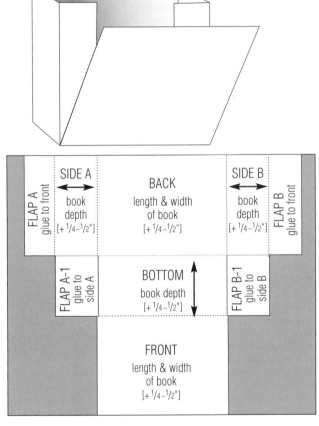

TEMPLATE 1
CUT on solid lines. FOLD on dotted lines.

Slipcase with a Flap

You might want a slipcase that closes completely, like a box. If so, refer to Template 2. The only difference from Template 1 is the section that folds across the top and the overhanging flap. The flap can be any size you wish, large or small, so no measurement is given in the template. This design requires a larger piece of paper than the first, so check your measurements carefully before you start to cut. Follow the same steps described in the Basic Procedure for Template 1.

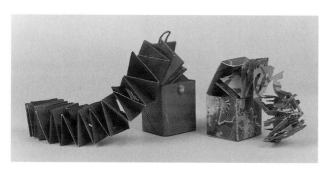

15–4 These fold-out books are contained within a box made from decorated watercolor paper. The books literally pop out of the boxes when they are opened.

Dan Hoffman and Ann Ayers, *Untitled Books in a Box*, 1996. Watercolor paper, 3 x 3 x 3" (7.6 x 7.6 x 7.6 cm).

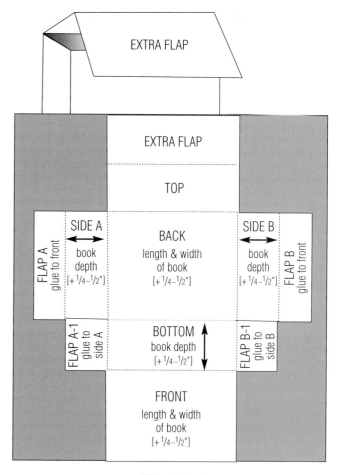

EXTRA FLAP

EXTRA FLAP

TOP

SIDE A	BACK	SIDE B
book depth [+ 1/4–1/2"]	length & width of book [+ 1/4–1/2"]	book depth [+ 1/4–1/2"]

FLAP A glue to front

FLAP B glue to front

FLAP A-1 glue to side A

BOTTOM book depth [+ 1/4–1/2"]

FLAP B-1 glue to side B

FRONT
length & width of book
[+ 1/4–1/2"]

TEMPLATE 2

CUT on solid lines. FOLD on dotted lines.

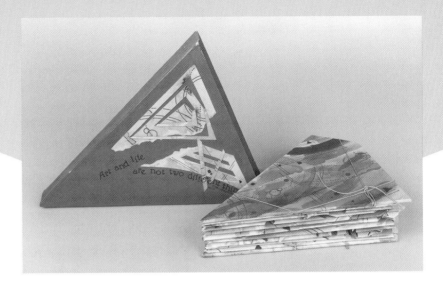

Slipcase for a Radial Book

Once you get the hang of it, you can make a slipcase for your book no matter what shape it is. You may need to start by tracing the shape of your book onto test paper and working it out step by step. The radial book can seem a bit tricky, so use Template 3 to get you started. Although it may look complicated, the cutting, folding, and gluing procedure is the same as for Template 1.

15–5 This slipcase, constructed from posterboard, houses a closed radial book. Paper scraps from the construction of the radial book were used to decorate the exterior of the slipcase.

Ellen McMillan, *Art and Life*, 1994. Watercolor paper, posterboard, mixed media, 11 x 8 x 2" (27.9 x 20.3 x 5.1 cm).

FLAP A glue to front

SIDE depth of book
[+ 1/4–1/2"]

FRONT
size of book
[+ 1/4–1/2"]

SIDE

FLAP B glue to back

BACK
size of book
[+ 1/4–1/2"]

TEMPLATE 3

CUT on solid lines. FOLD on dotted lines.

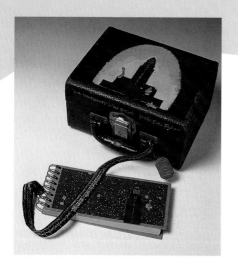

15–6 Keep an open mind when considering a slipcase. This artist uses a small suitcase to house her book when not on display.

Sandra Ortiz Taylor, *Winifred Box—Her Story*, 1993. Mixed media, 5 ¹/₄ x 10 x 8 ¹/₄" (13.3 x 25.4 x 20.9 cm), book 4 x 9" (10.2 x 22.9 cm).

Tips and Variations

Although posterboard is used in the previous examples, slipcases can be made from many different types of boards, including illustration board, museum board, Bristol board, or mat board. The standard procedure for constructing the slipcase remains the same. Because the thickness of the boards will vary, you may need to score the board before folding.

Scoring helps you to bend the board in the direction you want. Often, just running the edge of scissors along the fold line is enough. If the board is very thick, you may need to cut over halfway through the thickness of the board with a craft knife. The trick, of course, is to avoid cutting all the way through the board. If you are new at this, it's a good idea to practice on some scrap pieces of board. The scored line should be made on what will be the outside of the fold. If you don't

15–7 This slipcase was designed to be displayed alongside the sculptural book. Constructed from posterboard, it can slip over the closed book. (See this artwork in color in chapter two.)

Toby Schwait, *Egypt Revisited Slipcase*, 1992. Posterboard, 12" (30.5 cm).

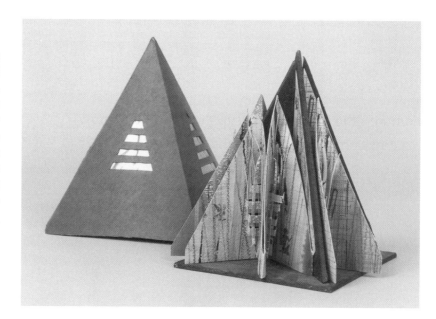

like the way the folds look, or if a fold becomes weak, you can reinforce the edges by applying decorative tape or by gluing a thin layer of paper along the fold.

Depending on the shape and design of your book, many slipcase variations are possible. Flaps can be held closed with Velcro, snaps, ties, or whatever suits your fancy. Artists have made slipcases from cloth, paper bags, acrylic, steel cans, metal or wood, to mention just a few materials. Take a look around you and keep an open mind. You never know what might inspire your next creation!

15–8 (Above left) An acrylic box becomes the slipcase for this artist's book. The case not only protects the work but allows us to see the book even when it's closed and put away.

bruce gambill, *Travois Labyrinth*, 1991. Acrylic, mixed media, 8 x 12 x 14" (20.3 x 30.5 x 35.6 cm).

15–9 (Above right) This artist made a cloth bag to hold her accordion book, seen folded at bottom. Sunflower images from the book's theme are repeated on the slipcase.

Kim Little, *Strong Knots with Loose Ties*, 1996. Watercolor paper, cloth, mixed media, 8 x 10" (20.3 x 25.4 cm).

Resources

Glossary

abstract Nonrepresentational art based on shapes and designs. The subject is not necessarily recognizable.

artist's book A book made by an artist; a book that is a work of art in itself. An artist's book may or may not contain words.

background The part of the picture that is the furthest away from the viewer.

boards The generic term for cardboard, tag board, or other materials used for the covers of a book.

chipboard A strong, gray cardboard that is available in different thicknesses, most commonly 2- or 3-ply.

complementary colors Hues that are opposite each other on the color wheel. Red and green, blue and orange, and yellow and violet are examples of complementary colors. When two complementary colors are mixed together, a neutral brown hue is created.

cool colors Hues that evoke the feeling of coolness. Blue, green, and violet are examples of cool colors.

cutting mat or board Special mats used as a cutting surface, designed not to dull knife blades. Some vinyl cutting mats are self-sealing.

dye A permanent coloring used to tint fabric.

endpaper The paper on the inside of the front and back covers of a book.

foreground The part of the picture plane that is the closest to the viewer.

format A book's design: its size, style, page layout, typography, and binding.

in-the-round Refers to a piece of sculpture that can be viewed from all sides.

media Materials used for creating art.

mixed media More than one type of material used to create a piece of art.

paint pen An opaque markerlike drawing instrument that contains paint instead of ink.

radial book A book that starts as a circular format, with each fold radiating from the center of the circle outwards (along a radius).

scoring Using a tool to cut or crease heavyweight paper or board so it can be folded more easily.

sculpture A three-dimensional artwork.

slipcase A covering made to protect a sculptural book.

spine The book's back edge, where the pages are sewn or glued together.

texture The way a surface feels to the sense of touch, or how it may appear to the sense of sight—for example, rough, smooth, furry.

transparent Refers to a material that can be seen through.

warm colors Hues that evoke the feeling of warmth. Red, orange, and yellow are examples of warm colors.

watercolor Transparent paints that are mixed with water.

watercolor paper A type of paper made for watercolor painting. Various weights are available, with the higher weight being the heavier paper.

weight down To place a heavy object on top of the cover to prevent the paper from bubbling while it is drying.

white glue A type of adhesive that is white when wet, yet dries invisibly.

Bibliography

Blake, Kathy and Bill Milne. *Making and Decorating Your Own Paper*. New York: Sterling Publishing Co., Inc., 1995.

Boca Raton Museum of Art. *Books As Art*. Riviera Beach, Florida: Graphics Illustrated, 1991.

Castleman, Riva. *A Century of Artists Books*. New York: Museum of Modern Art. Distributed by Harry N. Abrams, 1994.

Chatani, Masahiro. *Paper Magic: Pop-up Paper Craft*. Tokyo 162, Japan: Ondorisha Publishers, 1988.

Drucker, Johanna. *The Century of Artists' Books*. New York: Granary Books, 1995.

Jackson, Paul. *The Encyclopedia of Origami & Papercraft Techniques*. Philadelphia: Running Press, 1991.

Jackson, Paul. *The Pop-Up Book*. New York: Henry Hold and Company, 1993.

Johnson, Paul. *A Book of One's Own*. Portsmouth, New Hampshire: Heinemann, 1990.

Johnson, Paul. *Literacy through the Book Arts*. Portsmouth, New Hampshire: Heinemann, 1993.

Johnson, Pauline. *Creative Bookbinding*. New York: Dover Publications, Inc., 1963.

Kropper, Jean G. *Handmade Books and Cards*. Worcester, Massachusetts: Davis Publications, 1997.

La Plantz, Shereen. *Cover to Cover*. Asheville, North Carolina: Lark Books, 1995.

Lyons, Joan, ed. *Artists' Books: A Critical Anthology and Sourcebook*. Salt Lake City, Utah: Peregine Smith Books, 1985.

Maurer-Mathison, Diane. *Decorative Paper*. New York: Friedman Publishing Group, 1993.

Maurer-Mathison, Diane. *Papercraft*. New York: Friedman Fairfax Publishers, 1995.

Roukes, Nicholas. *Sculpture in Paper*. Worcester, Massachusetts: Davis Publications, 1993.

Shannon, Faith. *Paper Pleasures*. New York: Grove Weidenfeld, 1987.

Shepherd, Rob. *Hand-made Books*. Tunbridge Wells, Kent, England: Search Press, 1994.

Souter, Gillian. *Papercrafts*. New York: Crown Trade Paperbacks, 1994.

Stowell, Charlotte. *Making Books*. New York: Kingfisher, 1994.

Zeier, Franz. *Books, Boxes and Portfolios*. New York: Design Press, 1990.

EM–1 This nontraditional sculptural work stretches the meaning of the word *book*. As letters float in the water, new words form and disappear. By combining new elements—water and space—the artist has truly created a new type of book in sculptural form. In 1995, the artist's snowglobe bookworks were recognized by the National Endowment for the Arts.

William Harroff, *The Scarlet Letter,* 1995. Snowglobe bookwork, 4 1/2 x 3 x 3" (11.4 x 7.6 x 7.6 cm). Photography credit: Red Elf.

Supplies

Strathmore 400 Series Watercolor Paper

- Sold in 22 x 30" sheets as well as in blocks and pads.

- The preferred weight for sculptural books is 130 lb.

- Has a strong, rough finish and can withstand repeated layering of colors.

Createx Fiber Reactive Dyes

- Excellent color and lightfast qualities.

- Sold as a concentrated liquid. Mix with water to achieve the desired hue and value. Can be mixed to make new colors.

- Basic colors are turquoise, magenta, golden yellow, violet, and forest green. Many other colors are available.

Professional Colored Pencils

- Sold in sets of 12 to 105 colors.

- Premium quality pencils that lay down rich, vivid colors.

- Have soft, smooth, thick leads for easy shading and blending.

- Are resistant to fading when exposed to light.

Scissors

Lightweight surgical stainless steel scissors are sold in a variety of sizes and cutting edges; these scissors cut anything from silk to tag board!

Suppliers

Dick Blick Art Materials

P.O. Box 1267
Galesburg, IL 61402-1267

(800) 828-4548

http://www.dickblick.com

This mail order company is a complete source for most of the supplies needed for sculptural bookmaking: watercolor paper, scissors, dyes, colored pencils, rulers, white glue, craft knives, and chipboard.

NASCO

901 Janesville Avenue
P.O. Box 901
Fort Atkinson, WI 53538

(800) 558-9595

http://www.enasco.com

This catalog company has a complete listing many of the art supplies needed for bookmaking.

Sax Arts and Crafts

2725 S. Moorland Rd.
New Berlin, WI 53151

(800) 558-6696

http://www.saxarts.com

An art supply company that sells on the Internet and through mail order. This company is a comprehensive source for all art supplies including those needed for sculptural bookmaking.

Index